THE REAL WORLD™

CONFESSIONS FROM SIN CITY

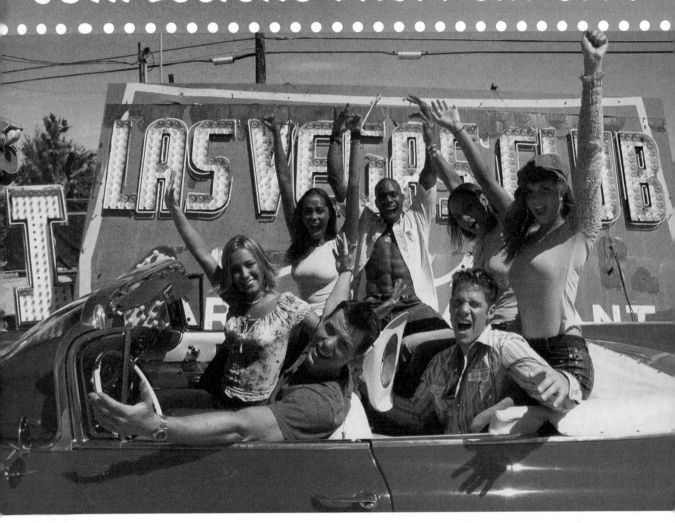

K. M. SQUIRES

books™ POCKET BOOKS

NEW YORK LONDON TORONTO SYDNEY SINGAPORE

Photos provided by: Rudy Archuleta, Erin O'Boyle, Jay Boucher, Ariana Urbont, Bunim/Murray Productions, and the cast and crew of *The Real World—Las Vegas*.

An *Original* Publication of MTV Books/Pocket Books

POCKET
BOOKS BOOKS™

POCKET BOOKS, a division of Simon & Schuster, Inc.
1230 Avenue of the Americas, New York, NY 10020

ISBN: 0-7434-5724-2

First MTV Books/Pocket Books trade paperback printing December 2002

10 9 8 7 6 5 4 3 2 1

POCKET and colophon are registered trademarks of Simon & Schuster, Inc.

For information regarding special discounts for bulk purchases, please contact Simon & Schuster Special Sales at 1-800-456-6798 or business@simonandschuster.com

Book and cover design by pink design, inc. (www.pinkdesigninc.com)

PRINTED IN THE U.S.A.

SPECIAL THANKS TO...

Scott Freeman, Vice President, Creative Affairs for Bunim/Murray Productions

Mary-Ellis Bunim, Jonathan Murray, Tracy Chaplin, Amanda Ayers Barnett, Ariana Urbont, Jacob Hoye, Becky Morrison, Dalita Keumurian, Alison Pollet, Michael Applebaum, Dr. Laura Korkoian, Jeff Keirns, Reginald LaFrance, Andres Porras, Brett Alphin, Michael Pepin, Chris Powell, Leah Cole, Doyle Lee, Rollen Torres, Stephanie Penner, Marc Portugal, Jean Nedel, Gina Boccadoro, Noah Pollack, Joyce Corrington, Tyler Knight, Corey Marsh, Erin Paullus, Matt Ruecker, Benjamin Greenberg, Tom Hoppe, Fabrice Guillaume, Andrea Glanz, Michelle Gurney, and Elizabeth Vago. And especially Alton, Arissa, Brynn, Frank, Irulan, Steven, and Trishelle.

Contents

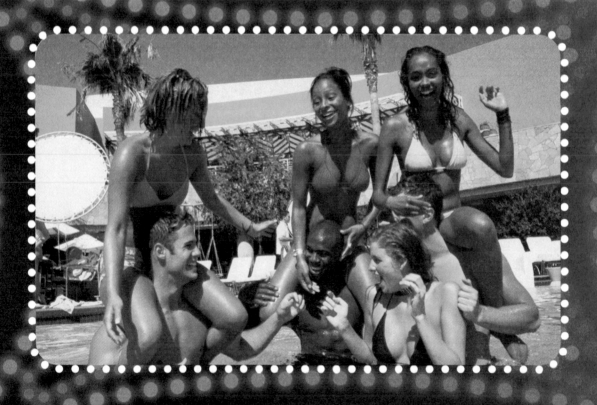

SEASON TWELVE
Talk

MARY-ELLIS BUNIM, CREATOR AND EXECUTIVE PRODUCER: *This season completely pushes the envelope. It's going to surprise people the way* Sex and the City *did when it premiered.* The Real World—Las Vegas *takes it even a step further. The cast was very comfortable with their sexuality. And they also had a natural and immediate attraction to each other.*

SEASON TWELVE
Talk

JONATHAN MURRAY, CREATOR AND EXECUTIVE PRODUCER:

I like to call The Real World–Las Vegas a sex comedy. We had relationships before, but this year it just got out of control. This year we had fascinating relationships and interesting triangles in terms of people's feelings about each other.

THE REAL DEAL
ON
The Sin City Seven

Alton

Brynn

Trishelle

IRULAN

Arissa

FRANK

Steven

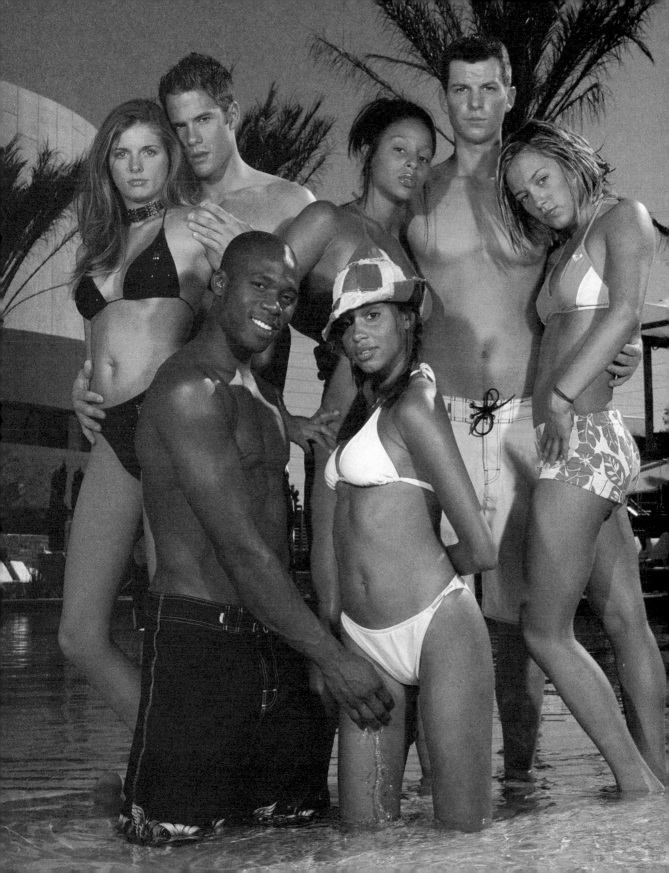

FRANK

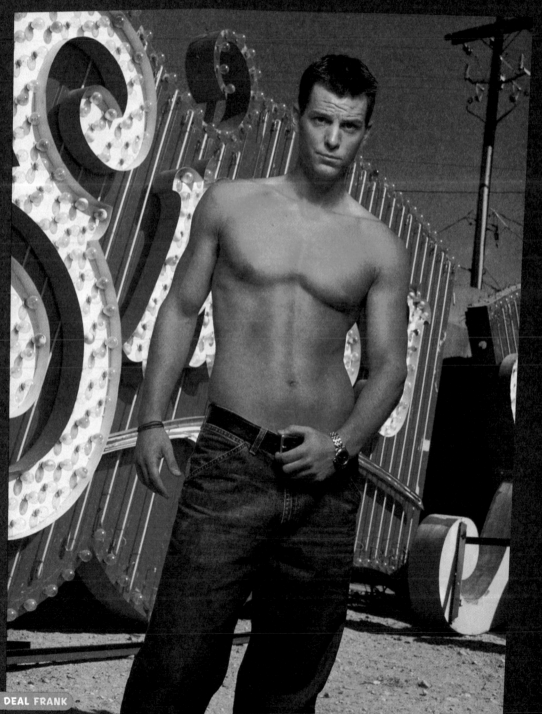

WHEN I GRADUATED FROM COLLEGE I HAD THE PERFECT LIFE. I HAD THE PERFECT GIRLFRIEND, THREE OR FOUR JOB OFFERS IN NEW YORK, AND I WAS LOOKING FORWARD TO A NICE, BORING LIFE.

Then I looked at my dad. He was a cop in New York for 20 years. At the same time he was a cab driver, and before that he was in the military. Because of his background, he has a million great stories. I'm 22 years old. I went to high school, then got drunk at Bucknell for four years. What kind of a life is that? I can get back to my career path someday. But for now, I want a couple more adventures. I want my own stories.

I'll admit, being on *The Real World* was like four and a half more months of college, only there was a lot more excitement. So I would do it again any day. I'm glad I did it and I'm leaving without regrets. I was 100% myself. My personality and opinions were all genuine Frank. The thing is, when I'm myself, I'm embarrassing myself. So I did that—for four and a half months. The problem with that is in real life if I'm embarrassing myself, only 20 people know about it. On *The Real World*, a million people will watch me embarrass myself. But it'll be something to laugh about, and I can't think of a single thing I'd do differently.

I hope in the edits the real Frank comes through because he's a good guy. But I think that's kind of impossible. I remember watching the L.A. season, and when it was over I really felt like I knew everyone on the show. Then when I went through this experience I realized that after filming 24/7 there are only about twenty-three minutes of airtime per episode, of which I am only 1/7. So how could anyone really know who I am? They are just going to know what's presented on TV. It doesn't mean that they're skewing anything, it simply means they don't have enough time and it's not all about me.

No one will see my ambition when the show airs because the only things I did in Las Vegas were workout, party, and eat. I worked my ass off in college, and then applying to graduate school. The months in Las Vegas were the least productive of my life. People are probably going to think I am some lazy college kid who doesn't do anything. But I'm going to be proud of every episode no matter what is shown.

I know my roommates didn't really think I put a lot out there because I really didn't like to get into confrontations with everyone. I considered this whole experience a blessing and I just wanted to ride the wave out and have fun. When I arrived in Las Vegas I was not at a good point in my life. I was pretty depressed and going through some rough times. But I left my problems behind from day one and started having fun. I got my smiles back and that felt great. The last two months all I did was laugh and

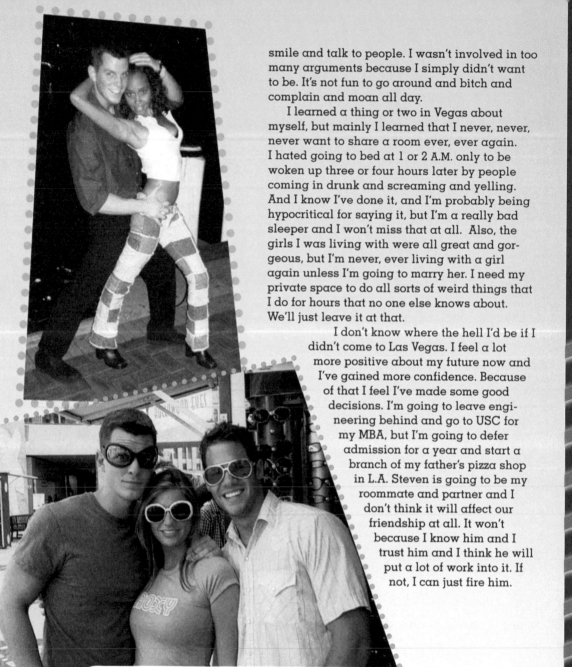

smile and talk to people. I wasn't involved in too many arguments because I simply didn't want to be. It's not fun to go around and bitch and complain and moan all day.

I learned a thing or two in Vegas about myself, but mainly I learned that I never, never, never want to share a room ever, ever again. I hated going to bed at 1 or 2 A.M. only to be woken up three or four hours later by people coming in drunk and screaming and yelling. And I know I've done it, and I'm probably being hypocritical for saying it, but I'm a really bad sleeper and I won't miss that at all. Also, the girls I was living with were all great and gorgeous, but I'm never, ever living with a girl again unless I'm going to marry her. I need my private space to do all sorts of weird things that I do for hours that no one else knows about. We'll just leave it at that.

I don't know where the hell I'd be if I didn't come to Las Vegas. I feel a lot more positive about my future now and I've gained more confidence. Because of that I feel I've made some good decisions. I'm going to leave engineering behind and go to USC for my MBA, but I'm going to defer admission for a year and start a branch of my father's pizza shop in L.A. Steven is going to be my roommate and partner and I don't think it will affect our friendship at all. It won't because I know him and I trust him and I think he will put a lot of work into it. If not, I can just fire him.

REALITY CHECK

Steven and I planned on moving in together, but Steven then thought it might be a better idea to stay in Texas and finish up his education there. So I came right to L.A. and got an apartment with my friend. But then Steven changed his mind, but I was already settled in my situation. So, we're not living together but we hang out every day. We're not doing the pizza place plan, either, because I'm going to go back to school.

CAST SPEAK

IRULAN: Frank is hysterical. We've had a few moments together where he shared things about his life and I've been able to do the same. But Frank has done a very good job of staying removed from all of the drama in the house. It seems that he came into Vegas really unhappy with his situation and the choices that he made. Being there sort of put things in perspective and taught him a lot about what he wants and who he is and how to appreciate and enjoy life. And I think he left a much happier person. That's amazing to watch and amazing to know. He's really smart and I have full confidence in him that he's going to do something great. We're not super close, but I very much respect him and I appreciated his presence in the house, and I plan to keep in touch with him.

ALTON: Frank is loud and he loves to talk. But he's a good and really cool person. I will definitely stay in touch with him.

BRYNN: My first impression of Frank was that he was some kind of fraternity jock. And my last impression is that he's a dork. But he's a cool dork. He's a good guy, super smart, and very sweet. I probably won't keep in touch much with him, though. I think that we're cool with our friendship the way it is and he probably won't go out of his way to call me, and I probably won't go out of my way to call him—except maybe on his birthday.

ARISSA: I call Frank "Amish Boy" or "Jebediah." I think I called him a Mormon, once, too. That's what I first thought. I thought he would be a goon with no sense of humor. I left Las Vegas thinking that Frank is the funniest person I've ever come across, and yes, I'd like to keep in touch with him.

STEVEN: Frank has been the same guy from day one. He's a funny, All-American guy, a very decent human being, and a great friend. We were going to move in together in L.A. I can't escape that bastard.

TRISHELLE: My first impression of Frank was that he was an only child who doesn't know how to do laundry who is probably going to lay on the couch all day and eat potato chips and expect us to do everything for him. He's not like that at all. He is the nicest guy ever, with the biggest heart and a great sense of humor. He's also very honest and he's been a great friend to me. I definitely will be in touch with him because I'm moving to L.A., too.

CREW SPEAK

MARY-ELLIS BUNIM, CREATOR AND EXECUTIVE PRODUCER: Frank is hilarious—a non-stop quote machine. He's very smart and he uses his humor in a self-effacing way. That takes trust on his part because he didn't know how far we would stretch that and make him look sort of dorkish. We went with what he gave us and that was an ability to really comment on himself and other people. He tends to be delicious punctuation throughout the series.

JONATHAN MURRAY, CREATOR AND EXECUTIVE PRODUCER: Whenever we needed a laugh we put Frank in the edit. I think people are going to empathize with him, especially because his game with the ladies wasn't quite as good as Alton's or Steven's. He's a nice guy. And nice guys don't always win.

TRACY CHAPLIN, PRODUCER: Frank came to Vegas and was in a really bad place with some of the prior troubles he had back home. I think he was in a bit of a depression and he felt like his life wasn't going where he wanted it to. I get the sense that Frank had no control over these past situations and he realized that there was nothing he could do about it but put those things behind him and take a no-cares attitude. And his friendship with Steven completely rejuvenated him. He's much happier and his outlook on the future is much brighter now.

Arissa

I DIDN'T PARTY MUCH IN MY PRE-REAL WORLD LIFE. I WOULD GO OUT ONLY ONCE OR TWICE A MONTH AND THAT'S BECAUSE I WAS IN A ROUTINE WHERE I WENT TO WORK, CAME HOME, WENT TO SLEEP, AND WENT TO WORK AGAIN. THEN I GET TO LAS VEGAS AND I REALIZE THAT I CAN PARTY EVERY SINGLE NIGHT WITH NO REPERCUSSIONS WHATSOEVER. I THOUGHT, OKAY, LET ME TRY THAT OUT AND SEE HOW THAT WORKS.

I'm going to enjoy watching us have fun the most. Not only the going out, but running through the house, speaking in retarded voices, jumping up and down on each other, chasing each other—all of that crazy stuff. We had so many jokes, and I think as a group we were really fun. So I hope that on the show, the fun stuff will even out all the drama.

In many ways, the *Real World* experience was like I expected, and in other ways, not at all what I expected. There's no way to prepare for it, and it's a huge adjustment. But after four and a half months, leaving the suite became a big adjustment, too, because I am going to miss living with these people! I really will. I'm going to miss getting up and wondering, *where is everybody? Is Trishelle at the spa? Are Irulan and Alton at the movies?* I liked always having someone around to do things with. And looking at life through everybody else's eyes was a really good thing to do for me. I looked at the way Frank sees life, and the way Alton sees life—and their ways of seeing were very different from mine.

Everybody surprised me in some way, shape, or fashion. I didn't know that Steven was so passionate. I didn't know that Alton was quite as talented as he was. I didn't know that Trishelle was as strong as she was.

I guess I'm the only roommate that's not really leaving Las Vegas. I plan to stay here and work for a while. And as much as I'm going to miss my roommates and the whole *Real World* experience, it will be great to be a normal person again, relax, and put together a plan.

If I had a chance to rewind and do it over, I think I wouldn't try to escape the cameras—I would just go with it more. Oh, and I would *definitely* have come into the experience single. That was a mistake on my part. But those are the only things I would change. I wouldn't change the way I behaved at all, because that's the real Arissa. I know I can come off as hard-

edged, but I hope that the compassionate side of me comes across, too.

I learned so much in Suite 28101. Everyone here taught me to look at myself and my actions. I learned how to deal with people. I learned how to end a conflict without anger, and that was important for me because I have a very bad temper and I am very stubborn and it is very hard for me to see somebody else's point when I feel that I am right.

The experience changed me in all good ways. I am much more positive now. I know now

what it is I want from life and that I can go get it. Getting out of my comfort zone in Boston allowed me to recognize that I can do anything, anywhere, anytime—forever. It might be hard for a lot of people in my life to deal with the way that I am now because I have been away for so long, but I am a better Arissa now, even if it is a different Arissa.

Reality Check

Jean Nedel, my ex-boss, offered me a job and I'm going to work with him in Vegas for a while.

on Arissa

CAST SPEAK

TRISHELLE: When Arissa first walked through the door I was like, she has sunglasses on at night? Who does this girl think she is? I thought, this will probably be the girl I'll fight with the most. And it was the exact opposite. She is the girl in the house that I liked the most. She's very easy to talk to and I felt very comfortable telling her things I couldn't tell other people. I look forward to keeping in touch with her.

STEVEN: When Arissa first came I thought she was a bitch. I even told her that. Every time I was around her I'd feel uncomfortable, and I was just waiting for her to yell at me. But after the first month I think she looked at herself and said, "Damn, this isn't good," and she did a complete 180. She's a sweet, sweet girl and I love Arissa now. She can do whatever she wants—there's nothing that girl can't do. I didn't extend this to everybody but I told her that if she wants to visit L.A. she has a place to stay. That's because I want Arissa in my life.

FRANK: The first week Arissa and I were friends, and then she turned into this horrible bitch. She became the meanest girl I've ever met. And then we had this amazing talk about a month into it and I've never seen anyone change the way she did. I think she realized that she isn't a bitch and she doesn't like being so dramatic. It was just that she was scared and her defenses were up, and that's why she was so quick to snap on everyone. Since that day she has been the sweetest girl I've ever met. Just seeing her in a room puts me in a better mood, because now she's always the happy one and little simple things always seem to amuse her. I'd love to keep in touch with Arissa because just being around her helps me out when I'm depressed. And she's such a hot girl. I want to marry her.

BRYNN: I was scared of Arissa when I first saw her. She's very pretty and she was intimidating at first. But my last impression of Arissa is that she's very emotional, very smart, super sweet, and she means well. I want her to go somewhere in life, and I just know she will. I think I'll call her once or twice a year to see how she's doing and how her life is going.

ALTON: When I first met Arissa I knew she was my homey. Our first night here we were freestyling at Rain and I was like, Wow—she's a beautiful girl, *and* she rhymes, and I feel comfortable just sitting and talking with her. I knew we'd get along. I will definitely stay in touch with her. She's dope.

IRULAN: Arissa came in very hard, with a lot of issues, but eventually she came out of her cocoon and she's a butterfly now. I think that she still has to work at feeling like she deserves certain things and that she's capable and that she's loved and people aren't going to turn their backs on her. Being taken out of her environment has allowed her to grow and learn about the things she wants and the person she can be. I think a lot of our relationship was about listening and being there for support and not letting one another do things that are self-destructive. And while we have a lot in common, we have a lot of differences, but I hope we stay in touch.

CREW SPEAK

MARY-ELLIS BUNIM: Some of the very interesting material we've been watching in the daily cut, which is the long form of the twenty-two minutes that gets on the air every week, are Arissa's conversations with Irulan. They were very comfortable with each other and a little competitive. They were able to sit down and let themselves go in conversation and it was enormously interesting to me.

JONATHAN MURRAY: There's a vulnerability to Arissa that's just endearing. You want to reach out and hug her because she just looks like someone who needs that. At the same time she's so strikingly beautiful, so articulate, and so funny. She's one of those people you root for.

TRACY CHAPLIN: I hope that Arissa has built herself a nice foundation to help take herself out of the projects. Coming to Las Vegas, Arissa has found that she has the skills and the strength inside of her to come away from the projects and make a life for herself elsewhere. I definitely think she has it in her to do that.

Trishelle

IF I HAD A CHANCE TO DO *THE REAL WORLD* ALL OVER AGAIN, I WOULD DEFINITELY NOT DRINK EVERY SINGLE NIGHT. THE DRINKING WAS TOO MUCH, AND THAT WAS THE BIGGEST MISTAKE EVER BECAUSE IT GOT IN THE WAY OF GETTING TO KNOW MY ROOMMATES ON A PERSONAL LEVEL. I DO PARTY BACK HOME, IN COLLEGE, BUT I ALSO WAKE UP EARLY AND GET MY STUFF DONE AND IT MAKES YOU FEEL GOOD WHEN YOU ACCOMPLISH THINGS. IN VEGAS, WE SLEPT ALL DAY, WE PARTIED ALL NIGHT, AND IT DIDN'T MAKE ME FEEL GOOD ABOUT MYSELF NOT REALLY DOING ANYTHING BUT. THE FEW TIMES WE DIDN'T GO OUT WERE TRULY THE BEST TIMES.

It's going to be the hardest for me to watch the times when we got so drunk we didn't remember what we did the night before. And that sucks, but I did it—that's me on film. I know that the real Trishelle does not get drunk every night. That's Las Vegas Trishelle and a choice that I made in a certain, crazy environment. I want everyone to know that the choices I made on the show are not choices I would make in my normal life.

I come from a very modest background and my family probably won't like what they see. But I'm 22 and they don't have to like everything I do. I love my family, but I just feel like being in the *Real World* situation has made me see who I need in my life and who I need to remove from my life. If someone is not accepting of me then you know what? I don't need them. It will be interesting to see what happens when I go home to Cutoff. But I'm only planning on being there a few weeks before I pack up and move to L.A., where hopefully I'll find a job dealing with sports or music.

I was really naïve about other cultures and people with backgrounds different from mine before I came to Vegas, and I learned to be more respectful of people and their pasts. You never know what people have been through. And I also learned to be more confident in myself. I was so self-conscious at first, always saying "I don't know, I don't know," and acting dumb. But I'm not dumb. I go to college and I'm going to graduate and I'm no dummy and I'm learning to be more comfortable with myself.

I guess I was also naïve about the *Real World* process when I first came to Vegas. I honestly did not believe that we were going to be microphoned and filmed 24/7. Yes, the producer gave me the "rules" but I didn't read them.

on TRISHELLE

CAST SPEAK

STEVEN: Trishelle is a really, really sweet girl. I've always felt that. And she's just gorgeous! They don't get any better looking than that girl. We've had our ups and downs but I think she's great and I want her to be happy and I want her to find what she's looking for. I want her to be loved and loving someone and when she finds that person, that's going to be a lucky guy. I'm sure we'll be seeing each other in L.A.

IRULAN: I'm not as close with Trishelle and she's been a little bit of an enigma to me from the beginning. She came in a naïve, innocent Southern girl in my eyes. So I thought she came to Las Vegas to come out of her shell. But then, I thought I was making a snap judgment just because she's from a small town in the South. So, then I thought, maybe she's really a diva on the downlow and that's just like the Southern belle way of hiding things. And then I thought, no, she's a player, and I'm getting duped. What I do know about Trishelle is that she is very sweet and pretty easy to get along with. And I've had fun with her but I don't know if we've really broken down any of her walls. It seemed when other people in the house were going through things she was not there—she would get up and go somewhere else. And that's not because she's a bad person, or insensitive, but I got the impression that she just wasn't able to deal with it. We have a lot in common on how we both lost a parent at fairly young ages, and we did bond a few times. We're friends and we're cool, but we never really went past that first level. And I hope we'll keep in touch, even though she plans to be on the West Coast.

So I freaked out. I was like, "What? We can't turn out our own lights? What is this?" I didn't understand. And I completely underestimated my roommates at first. I thought everybody in the house was going to hate me. But I was wrong, and I fell in love with each and every person in the house.

Reality Check

I finally visited my mother's grave for the first time when I got home. It was a really, really big moment for me and I'm glad I did it. I really needed to.

ARISSA: I believed at first that Trishelle would never speak up and say what she felt or meant. In the end, I realized how strong Trishelle is. I plan on keeping in touch with her.

FRANK: I first thought Trishelle was just a hot girl, and not a very intelligent girl. But I've found that Trishelle is very intelligent. She just doesn't present herself that way sometimes. So many times when we were working as a group and she had a suggestion, she would preface it with, "This is probably wrong, but…" and then we would go, "Oh my God, Trishelle, that's a great idea!" I definitely think that me, Steven, and Trishelle were all pretty good friends on the show, so I think that will continue while we're in L.A.

BRYNN: Trishelle is the one at first that I didn't want to live with, and we ended up sharing a room. I leave knowing that she is a very genuine, good person and she has a good life ahead of her. I'll keep in touch with her. She's already said that we're going to be calling each other when the show airs. But we pinky swore that we're going to watch the first through the last episodes because our thoughts and feelings have changed a lot during that time. I said some stuff that I probably shouldn't have, but now I see her in a different light.

ALTON: When I first met Trishelle I thought she was very timid, and not very confident. But getting to know her I realized that she's kind of into herself, and that's probably because she's an amazing person. We'll keep in touch, though probably not as much as the others.

CREW SPEAK

MARY-ELLIS BUNIM: Trishelle was pretty comfortable with her sexuality from the beginning and she has a confidence in her beauty. She has a knowledge of the effect her beauty has on men—not to say that she's conceited, but she's aware of it.

JONATHAN MURRAY: We've noticed over the years that women from small towns have more sex than women from big towns. Maybe it's because there's not much else to do. She's a small-town girl, yet, because of her looks and the way she carries herself she can walk into situations and seemingly be comfortable in them. In the beginning she seemed to defer to her roommates, but then I think she gained a sense of self-esteem and some backbone and it was some good growth for her.

TRACY CHAPLIN: Trishelle came from a world where she didn't have exposure to different cultures, and for her to have this experience totally changed her life—it has helped her grow and to prevent her bias. It's going to be hard for Trishelle because she has strong family ties, but she will take this experience and use it to forge a really nice career and life for herself outside of Cutoff. And she can certainly go places.

Brynn

THINK I SAID I WANTED TO GO HOME EVERY DAY I WAS IN VEGAS. AND I WISH I HADN'T BECAUSE I FEEL IT BROUGHT ME DOWN A LEVEL. I ENJOYED MY TIME THERE BUT THERE WERE SOME POINTS WHERE I WAS JUST NOT HAVING FUN. I WISH I COULD HAVE LET THAT GO.

I didn't go home because it's a rarity that I finish anything that I start and I need to learn to finish things, even though there were so many down times, and even though there were so many times of me saying that I wanted to go home. Sticking it out and completing this process is a really big achievement for me.

I changed a lot during my time in Vegas. I saw the first episode and it was weird to see how I used to act. But that was really me and really how I was. I hope people will see me come in as one person and evolve into some-body better.

The Real World process exaggerated my anxiety because of the cameras and I was analyzing every situation way too much. Having a camera in your face 24/7 is a lot of pressure. That and having to put on a mic every day and to have all of these rules all of a sudden was very hard for me. I'm not used to having such structure imposed on me. But it wasn't only that—it was partly the process and partly the things that were going on in my life that brought on the panic attacks.

I hope that it can help a lot of other people that are going through a similar anxiety. When the show airs, I want people to understand panic attacks and that it's okay. I'm feeling a lot better now and once I really get settled back

into my own environment I'm sure my anxiety will calm down a lot. It's still there but it's not as intense as it was before.

This process helped me out a lot, though. It was kind of like speed therapy. While it was hard to go through, I think it was important for me to learn that I'm not as strong as I thought I was—to realize that I'm not as completely untouchable as I thought I was. It was also a good opportunity for me to reflect—not only on current situations but also on things I've done in the past to other people and to not be so judg-mental. I also understood that it was okay to ask for emotional support and to have people want to help you. Looking back on it now, I wish I would have been there more for other people in the house just as much as they were there for me. But I have to just move ahead now.

I'm looking forward to going home to Portland to spend time with my boyfriend and my friends and just do the things I normally do there. But I'm not sure where life is going to take me next. To put a finger on something—like going back to school or getting a certain

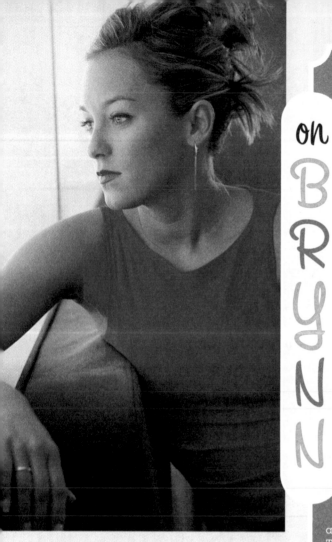

on BRYNN

job—is limiting myself. If I hadn't come to Vegas for *The Real World,* I probably would still be working as a dental assistant and I'd still be in a hum-drum, 9 to 5 life. I realized I'm only 21 and I don't want to be there just yet. So I'm just going to start over, and that's a really good feeling for me.

Reality Check

I'm moving to Hermosa Beach with Austin and a couple of my friends. I'll probably end up cocktailing on the beach, and will hopefully go back to school to get my degree in communications.

CAST SPEAK

ALTON: My first impression of Brynn was that she was kind of crass and cocky. And then leaving the house I thought she's not as cocky as I thought she was. She's still self-absorbed but it's not out of ego, it's because she's scared. She still doesn't see herself in the mirror but she's a wonderful, brutally honest person. Maybe too honest to herself. I hope we'll stay in contact.

STEVEN: Brynn came in a little headstrong party girl and turned out to be one of the strongest people in the house. I have a lot of respect for that girl. She fought a lot of obstacles and she continues to struggle but she's owning up to it, and she wants to be helped but she's not taking the easy out, not going for the quick fix. She's so young that I only see her growing in the right direction. I'm really proud of her and I wish her happiness. I think we'll keep in touch—I would love to see her boyfriend's band.

TRISHELLE: The first words out of Brynn's mouth were "I'd rather live with a boy. I don't want to room with a girl," and I was like, "Wrong thing to say, girl!" Then I ended up rooming with her. We didn't have the best relationship on the show—we were kind of at each other's throats often because we're both Scorpios. Two Scorpios rooming together, sleeping two feet away from each other—not good. But toward the end she was really honest with herself and I was very proud of her for how she dealt with a lot of things in her life. I'm not sure if we'll keep in touch—we'll see.

IRULAN: I couldn't stand Brynn when I first met her. She came into the house saying she didn't get along with girls and that she was a party animal and her middle name is Vegas. I thought, who does this chick think she is? But getting to know her has been such an incredible experience. Brynn turned out to be one of the closest people to me in

the house. Our friendship is very solid and something that makes me feel really good. I've watched her blossom from coming in with a nonchalant, protective edge to a more vulnerable, more open person. She stuck her neck out for me on many occasions and she's the person in the house who always speaks her mind regardless of what kind of response she's going to get and I respect her for that because it's hard to do. I love her and we'll stay friends.

FRANK: When Brynn came in, she just announced to the house, "I'm bisexual! I love to party! And I'm a bitch on top of it!" It turns out that she's not a bitch whatsoever. She's just a sweetheart. She's a little paranoid, but very easy to live with. And she's not that much of a party girl, either. She got a boyfriend while she was here and she just loves him to death. They're perfect together. Brynn is someone I think I really could be friends with, and that's kind of sad because I'm not sure if we'll stay in touch.

ARISSA: Brynn is a good person with a very good heart. She changed the most out of all of us, mellowing out her partying and reflecting on the things that she did during her time in Vegas. We'll stay in touch.

CREW SPEAK

MARY-ELLIS BUNIM: Brynn is enormously likeable. The Brynn that emerged from Vegas definitely has a lot more confidence than the girl who started. I'm so glad that she got through a couple of big challenges that she had to face with some of her roommates. They helped her grow.

JONATHAN MURRAY: Brynn is a bit of a lost soul. She's not sure what she wants in life but I think she's on her way to finding out. I think she previously lived her life through the men she's been involved with and she's now gained the self-confidence to make decisions based on what is right for her.

TRACY CHAPLIN: Brynn is a party girl—I'll give her that—but I expected her to be a little more outrageous. I admired watching her grow and learn about herself. She took us on a journey that I didn't expect to be taken on—I expected to see more of the party girl, but she really took the opportunity to look at herself change and grow into a remarkable woman.

Steven

I CAME FROM AN ENVIRONMENT THAT I HAD COMPLETE CONTROL OVER, WHERE I COULD DO WHATEVER I WANTED AND PICK MY FRIENDS. I CAME TO VEGAS AND I HAD SIX ROOMMATES THAT I DIDN'T CHOOSE, AND I COULDN'T CONTROL ANYTHING. AT HOME IN TEXAS, IF PEOPLE IN MY LIFE ARE NEGATIVE I JUST CUT THEM OUT OF MY LIFE. I COULDN'T ESCAPE SOMEONE IF THEY WERE BEING NEGATIVE IN LAS VEGAS. AFTER A WHILE, THE NEGATIVITY STARTS SEEPING INTO YOU. I DIDN'T LIKE THAT.

I came to Vegas really secure and happy with who I was. Living with six different people and constantly being made aware of my relationships with them made me feel so insecure. I struggled with my feelings about everything. My philosophy is that a lot of people tend to grab on to and dwell on the negative things and if good things happen they just let them pass by. I try to do the opposite. But *The Real World* atmosphere made it really hard for me to do. That's not how I like to live.

Midway through my roommates were talking about how I joke too much. I know it's a defense mechanism but it makes life more enjoyable. While I did joke a lot, I also had really helpful conversations with Arissa and Alton and I generally did try to help people. But when the show airs, I hope they show how funny I am. Drama gets old after a while and the comedy that was produced among the seven of us was terrific. Laughter is really the best medicine.

Whatever is shown, I hope that my actions won't cause my ex-wife and ex-mother-in-law any pain. I am still very close with them and I know they will always love and support me, but if I cause them any discomfort or pain it will hurt me. For example, it's not going to be easy for my ex-wife to see me hooking up. She knows I've hooked up in the past, and we are divorced, but knowing it and having to watch it are two different things.

I was so flattered to be a part of pop culture history—*Real World* was the first reality TV show. And the fact that I was on it validated that I might be an interesting person. It also made me realize that it's okay for some things to be out of my control. And I feel I got a great friend out of this experience in Frank. We've been inseparable for four months and the fact that we haven't killed each other by now means that we'll be great business partners in L.A. He's a really intelligent guy with an amazing work ethic, and if anything, Frank sets the bar for me. I'm up for it.

I'm hoping that I'll find a passion and find the time to pursue so many interests. I want to do everything, from learning martial arts to photography. But as long as I'm happy and as long as I'm enjoying myself on the trip it will all be worth it.

Reality Check

I'm living on my own in L.A. I see Frank every day, and Trishelle every few days. I'm hoping to get into UCLA and finish school there.

CAST SPEAK

FRANK: When I first met Steven I thought he was really immature. He was the oldest guy in the house at 23 but he seemed more like a 17-year-old. All he talked about was sex. I mean, that's cool but it's just immature. I don't think he was really acting like himself when he first got to Vegas. Then I got to know him really well and it turns out that our personalities are very matched up. I never thought I would appreciate his friendship like I do now. I like hanging out with Steven. I've got nothing better to do.

BRYNN: I first thought Steven was cute, cocky, and gay. My last impression of him is that he's a good guy, not gay, and still cute. I admire how he manages stuff for himself—that's really important. And I consider him one of my friends. I'll probably call him now and then.

ARISSA: I thought Steven was gay for about a second. That changed quickly. We had so much fun together after a while. We had a great time acting crazy together—it was great to find another crazy person who would participate with me. I will definitely keep in touch with Steven.

IRULAN: :Steven and I started out on a rocky little road. Something about me turned Steven off at first—he got it in his mind that he didn't like me. I was angry at him for not giving me a chance, but then he helped me take a closer look to figure out what wasn't going right in our relationship. Though we're still not super close, we have respect for one another. I very much appreciate his sense of humor and the fact that he is for the most part amiable. I also think, however, that Steven probably takes the least away from *The Real World* experience, but that might be because he did a lot of searching and a lot of changing right before coming to Vegas. It was a good experience for me to watch somebody who's generally just happy with life. I'm not sure if we'll keep in touch—it would be nice to.

ALTON: At first I didn't like Steven because I thought he was conceited. But in the end I thought he was a cool person. Will we stay in touch? We'll see….

TRISHELLE: My first impression of Steven was: pretty boy. And I thought he was conceited. Then I learned he's not conceited at all. Actually, he doesn't think enough of himself. Steven is a really awesome person, who is fun to be around. He and Frank together are the funniest people ever. I plan to see him when I'm in L.A.

CREW SPEAK

MARY-ELLIS BUNIM: Steven is an enigma to me. On one hand, he seems so open and vulnerable. And the next moment, I don't know where he's coming from. But I think this mysterious quality will draw viewers' interest. They'll want to figure him out.

JONATHAN MURRAY: Steven is one of those people that we could be here for two more years and not completely get everything that's going on with him. It will be interesting to see what comes of the *Real World* experience and what happens in his life.

TRACY CHAPLIN: Forging a friendship with Frank was important for Steven and nice to watch. From his background with so much moving around, I don't think he's had the opportunity to have a nice, solid friendship with a male. I think it's added some nice peace for Steven.

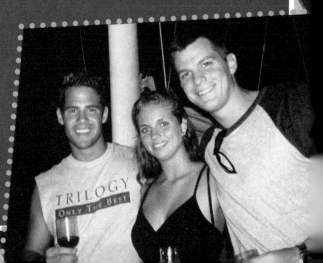

Alton

I NEVER WATCHED THE REAL WORLD SO I REALLY DIDN'T KNOW WHAT TO EXPECT WHEN I STEPPED INTO IT. AT FIRST I THOUGHT IT WAS GOING TO BE PARTY, PARTY, PARTY—WHICH WE DID A LOT OF, DON'T GET ME WRONG—BUT I THOUGHT IT WOULD BE MORE OF A SUMMER CAMP ENVIRONMENT. I WASN'T PREPARED FOR THE DRAMA.

If I could do it over again, I would probably step in the pool instead of jumping in and I wouldn't have been with as many girls. I also would have thought more of what I was saying while I was saying it to make sure it was exactly what I wanted to get across. Then I suppose I wouldn't have closed down as fast, because I'm very protective of myself and for me to give of myself it takes a lot.

I think I'll come off as a mystery man. I don't think anyone is going to watch the show and feel they have me pegged. They might see me as a player, and sometimes I might be crass or a bit of an a**hole. But what I want people to know is that I am a three-dimensional person. There are things that have been recorded, but also things that haven't been recorded that reflect who I am. I don't plan on watching it, so I won't really know how I come off. I didn't watch TV before Vegas and I don't plan on watching it now.

I learned so many things about myself during my time in Vegas. I learned that I am introverted and quiet, even though I can be loud, too. I learned not to judge people too harshly, because I'll admit I did a lot of that. I also learned to give emotions time and to let them settle before coming to a decision on how to handle a conflict.

Once I re-establish myself it's going to sink in and be weird to be away from my roommates and Las Vegas. I felt very safe there. There were always people around, and a bunch of security guards at the hotel looking out for us. I could walk around blind drunk and someone would put me in an elevator.

My plans are pretty up in the air right now. I definitely want to go back to school. I think I might move out to the East Coast to be closer to Irulan and see what that's like. I want to surf and travel and give myself time to keep moving before I settle back into school again, though. This whole experience derailed me and I don't know exactly where I'm going. I have so many options and it's overwhelming.

No matter where I end up, it's going to be weird not to have six people around. It's like graduating from high school. You wait for it to be over, but when graduation comes, you're like, Oh my God, what am I going to do now?

REALITY CHECK

Irulan and I are moving to Los Angeles together.

CAST SPEAK

on ALTON

IRULAN: Alton and I had some sort of connection from the beginning. We got to be really good friends then things turned romantic, then things got rocky, and then we realized there was *really* something there between us. He's a beautiful person both inside and out and he's a great friend, who's very supportive, and really loving. He's got a lot going for him. What I love so much about him is that he's so passionate and motivated about so many different creative and physical outlets. He skates, he rock-climbs, he plays the violin, he wants to go to medical school—he has all of these things he's juggling and he does them all well. I plan to have Alton in my life.

BRYNN: Alton is very handsome and charismatic but he's also very deep and genuine. He's very emotional and he knows where he wants to go and I hope that he can get there. I'll probably call him more than the other boys, because his family's on the West Coast. I feel like he'll be very appreciative—not that my other roommates wouldn't be appreciative of a phone call—but I think that he'll be a good person to call and see how he's changed. He is changing a lot emotionally and spiritually and I would like to see how that works out.

FRANK: My opinion of Alton has changed so many times. He's a really good guy. Very intelligent, funny, and he has so many good things about his personality. Alton has been through some rough times and because of that he does have a few things about his personality that are difficult to deal with. And these things are amplified when he's been drinking. When he gets drunk he can't control himself and he sometimes says things that are really rude. He was probably the person I had the most confrontations with, but though we had our bad times we got through it. We've talked and since then he's been very considerate. Because of that I respect who Alton is very much. I'm glad that we went through those things and

we discovered a better way to hang out together. He'll probably be in the L.A. area, so I would definitely like to see him every once in a while.

STEVEN: When Alton came in I thought he was one of the most talented people I've ever met and in the beginning I thought we were going to be really good friends. Now, I wouldn't mind if I never see him again. What changed? The person you project and the person you are are sometimes two different people. I'll leave it at that.

ARISSA: I called Alton "Save the Last Dance" because he reminded me of that guy from the movie. I thought he was going to be a goon at first but he turned out to be one of the most fun people I've ever come across. And he's so, so talented. We'll stay in touch.

TRISHELLE: My first impression of Alton was that he was a good Pentecostal boy. My opinion of him has changed a lot during the show, but ultimately, Alton is very compassionate and passionate and easy to talk to. We have a similar background and he's a really nice guy but I'm not sure if we'll be in touch.

CREW SPEAK

MARY-ELLIS BUNIM: Alton has a way with the ladies, and that didn't change during his time in Vegas.

JONATHAN MURRAY: And there's a sweetness to Alton that cushions his way with the ladies. We knew he had a preference for women of color and it turned out that two beautiful women of color were his roommates. It was interesting to see all of those relationships develop.

TRACY CHAPLIN: I've seen Alton grow and find happiness. I think finding Irulan has brought him a happiness that I don't think he had back home. He comes from a loving family, but to go through the pain that he did, there was a piece of him that was lost and I'd like to think that coming to Las Vegas and particularly being with Irulan may have filled some of that loss with happiness.

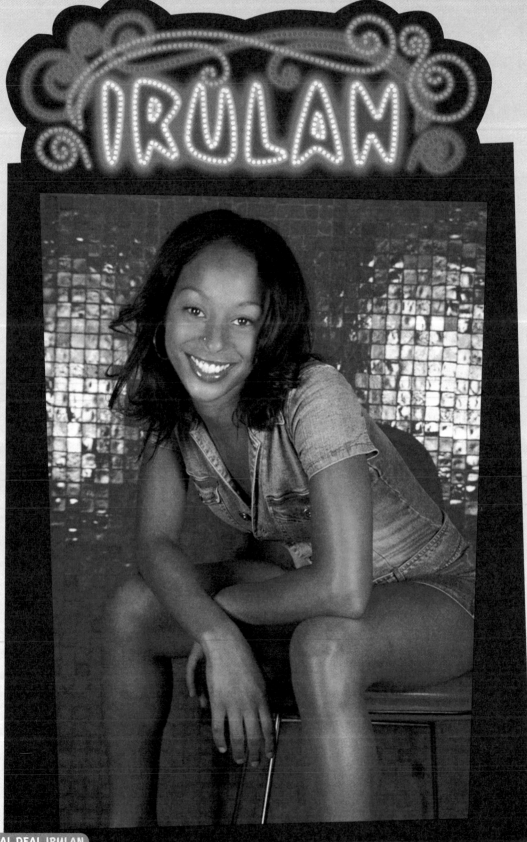

I HAVE A STRONG PERSONALITY. I'M VERY OUTGOING AND OUTSPOKEN AND I'M NOT AFRAID OF CONFRONTATION IF IT NEEDS TO HAPPEN. THE PEOPLE IN MY LIFE AT HOME KNOW THIS ABOUT ME AND ACCEPT THESE THINGS ABOUT ME. IF I SAY SOMETHING IN A SNAPPY WAY, THEY KNOW I DON'T NECESSARILY MEAN TO HURT SOMEBODY'S FEELINGS. I HAVE THOSE KIND OF ALLOWANCES FROM PEOPLE BACK HOME. IN VEGAS, I DIDN'T AT FIRST BECAUSE MY ROOMMATES DIDN'T KNOW ME. DEEP DOWN I'M A SENSITIVE PERSON AND I WANT PEOPLE TO LIKE ME, AND I REALLY WANTED MY ROOMMATES TO LIKE ME.

There were a few hard lessons I learned during my time in Vegas. I learned that when you make snap judgments about people you keep them in a tiny box, and it's very hard to let them out of that box and appreciate the entire package that they are. I also learned that you have to be considerate of other people's comfort levels and privacy—it's easy to get into each other's way and communication is really important.

There were a few times that I wanted to go home. I got to the point where I was just so fed up and I felt overwhelmed by the whole situation. I stayed because of long talks I had with my mom and Arissa. Plus, I didn't want to be a quitter. I didn't want to be that girl who went running home.

I wish I had allowed myself to come out to Vegas free of all ties from home. That would have allowed me to let my guard down easier in the beginning. The first two months I was very aware of the cameras and I didn't want to hurt anybody close to me, especially my boyfriend. Halfway through, though, I just let it go and I was really able to take a good look at myself and grow and change and learn. I think if you concern yourself too much with how you're going to come off to other people it inhibits you from really benefiting from this experience.

The two things that are going to be really hard for me to watch are Alton being with other girls, and the whole Gabe drama. I'm going to go home and have a long talk with Gabe to figure out where we are, what's changed, and what's going on. I won't know what things are going to be like with him until I go home. No matter what, we are very close friends.

I'm heading back to New York to finish school. I don't think I'm going to fully realize how much I've changed until I get home and resume a normal routine. Living with cameras and strangers, I was forced to see myself in a different way. Hopefully the benefits of that will last.

REALITY CHECK

Gabe is such a classy guy. He basically let me know that he loved me and that we'll always have one another in our lives. But Vegas and the whole experience let him know that we're not on the same page. He asked me one thing, and that was not to hook up with a roommate, and I couldn't comply. And he doesn't fault me for that. We are not together but we are definitely friends, but I think it will take some time for us to adjust to us being friends and not a couple.

CAST SPEAK

BRYNN: My first impression of Irulan was that she was not my type of person. My last impression is that she is very special and very strong and she's someone that I look up to. I'm so glad I had the opportunity to meet her and I think that we grew really close. I will probably visit her more than any of my other roommates.

ALTON: When I first met Irulan I thought she was a beautiful girl. I thought she was the type of girl, though, that expected every guy to fall down and be her footstool. I was wrong. Getting to know her, I found out that she is very humble. She's loving and giving and a beautiful person all around. I don't know where our relationship is going but we're very good friends and I hope we'll always be in touch.

ARISSA: I thought Irulan was exactly like me and I found out that she's not—and that's okay. In the end we weren't as close as when we started living together. People change and discover new things. She discovered Alton and you can't blame her—he's a great guy. I enjoyed spending as much time with Irulan as I did and I know we'll stay in touch.

FRANK: Irulan is a great person. She's very intelligent and I think we mutually respected one another. We've had no problems because of that. She had a fun time in Vegas and she really showed us who she was and I like who she is. We did not become the best of friends, but that's not a bad thing. Realistically, I'm probably not going to keep in good touch with her because she'll be on the other side of the country. But if we're ever in the same area it would be awesome to hang out with her again.

STEVEN: Irulan is a beautiful, beautiful girl and extremely talented—her photography is amazing. We had some trouble in the middle but I've got nothing bad to say about her— I think she's great and I like her a lot. She deserves everything she gets in life as long as it's positive. I wish her a good life and I'm sure we'll talk every once in a while.

TRISHELLE: I first thought Irulan was a Goody Two-shoes and I thought she was going to be kind of quiet. But she's really feisty and saucy and bouncing off the walls. She's loud, energetic, and lots of fun. We weren't really that close and I'm okay with that. I think we're always going to be friends and we'll be in touch, I just don't know for how long.

CREW SPEAK

MARY-ELLIS BUNIM: Irulan's commitment to Gabe and her attraction to Alton created very relatable drama. I know I was drawn in immediately about whether Irulan and Alton were going to get together, and I still can't wait to find out what happens!

JONATHAN MURRAY: Irulan is one of those people who likes to stir things up. If she saw something going on in the apartment that she didn't like, she immediately talked to someone about it. Coming to Vegas, she reaffirmed she had an open relationship with her boyfriend, Gabe, but there was some question about whether she promised not to hook up with someone in the suite. She and Alton instantly found each other attractive and we wondered from day one what was going to happen between them.

TRACY CHAPLIN: Irulan surprised me in her relationship with Gabe and I didn't necessarily see her relationship with Alton coming—I wasn't sure where she was in her situation with Gabe to pursue something with Alton. But there's a happiness that I see in her now which is a result of finding a companionship with Alton.

La Vida
LAS VEGAS

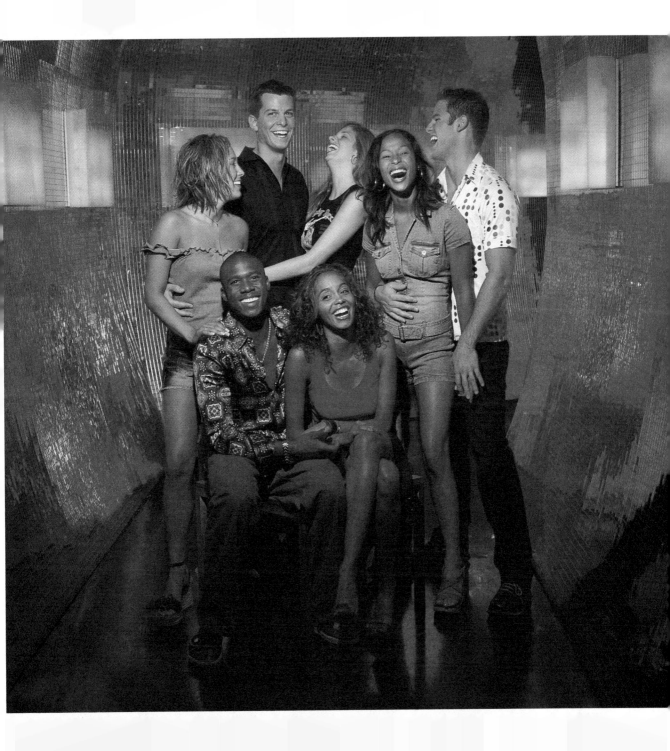

IRULAN: It's been a wild ride here in Vegas, but we've definitely had a good time. I look at it as a city of lost dreams. People come here in search of glitz, glamour, and money and there's so many who don't find those things. There's a lot of silicone, collagen, and general fakeness. But I've also known people in Vegas who are from there and they're more grounded and have regular lives. It's a weird sort of town, overall—an exaggeration of everywhere, all meshed together, without much diversity and culture.

ALTON: I definitely didn't see much culture, but that might be because we lived in a casino. You don't come to Vegas for culture, though, you come to Vegas to have fun. All of the movies I've seen about Las Vegas, like *Leaving Las Vegas* and *Indecent Proposal*, made me imagine people going there, losing their mortgage payments in blackjack, getting married and getting divorced a month later. And I guess my impression hasn't changed! It's a 24-hour town, non-stop, and a lot of people here seem to be trying to get one over on somebody. But I met a good person in Vegas for every slimy one.

FRANK: Most people who would be residents of Las Vegas wouldn't be living in a damn casino like us! Normal people live away from the Strip in an apartment complex and party on weekends. But for us, it was like some kind of eternal Spring break. We would either be drunk, or see drunk people all hours of the day and night, and you can't get away from it. After four and a half months I was really starting to get sick of it. I know now that I never want to go on Spring break again.

STEVEN: What's amusing about Las Vegas is that it has a lot of characters—anywhere you go there's always a mobster guy, a promoter guy, a blonde with big poofy hair and big fake boobs to match. They're all caricatures.

The 24-hour liquor has its effect on you. You see so much going on and so many things that you wouldn't normally do are accepted in Vegas. It wears away on what you think is appropriate.

ARISSA: Las Vegas caters to every addictive behavior: drinking, smoking, sex, gambling—you name it—so it's easy to get stuck there. It definitely brought out the sinner in me.

I don't feel that Las Vegas is a real city—it wasn't even supposed to be a city so it is very superficial. That's hard because you really have to look at people to find out whether they're real or fake. And everyone here is cosmetically enhanced in some way—men and women.

BRYNN: There's a lot of ruthlessness in Las Vegas and friends are very few and far between. People who live here step on so many others to get to the top, and everyone is about getting to the top. If you get outside the Strip, I hear it's really amazing, but I didn't get a chance to experience that.

I was so excited to come to Vegas at first. I was like, Vegas is my middle name and I was born and raised to live in Vegas. But after four and a half months, I'll admit it wore me out.

TRISHELLE: You have to not let Las Vegas corrupt you. It corrupted me! Since I'm Southern Baptist, everything in that city is a sin including living in a casino. Everything in my daily life there was considered a sin.

Sloth

BRYNN: *After four and a half months, I'll admit it wore me out.*

Gluttony

MARY-ELLIS BUNIM: *We were a little fearful of it—worrying that our cast would fall into a giant abyss of sin—and that prediction turned out to be true.*

MARY-ELLIS BUNIM: Vegas had been on our radar for a long time because it is America's #1 playground. We were a little fearful of it—worrying that our cast would fall into a giant abyss of sin—and that prediction turned out to be true. Fortunately, they've all emerged intact and with a real perspective on their experience.

JONATHAN MURRAY: I was concerned about doing *Real World* in Las Vegas at first because I didn't want it to be only about one thing—partying. There certainly was plenty of partying, but because we hit gold with casting we were able to get a lot of story about relationships, too.

TRACY CHAPLIN: The challenge for me in Vegas was that it is a 24-hour city. We've done New York, which is the city that never sleeps. Well, New York sleeps a few hours at least. Not so in Vegas. We worked around the clock because there was always someone who was awake. Very rarely were all seven of them asleep at the same time. We had to add an additional crew to make up for that.

Envy

Anger

Pride

Lust Greed

Greed

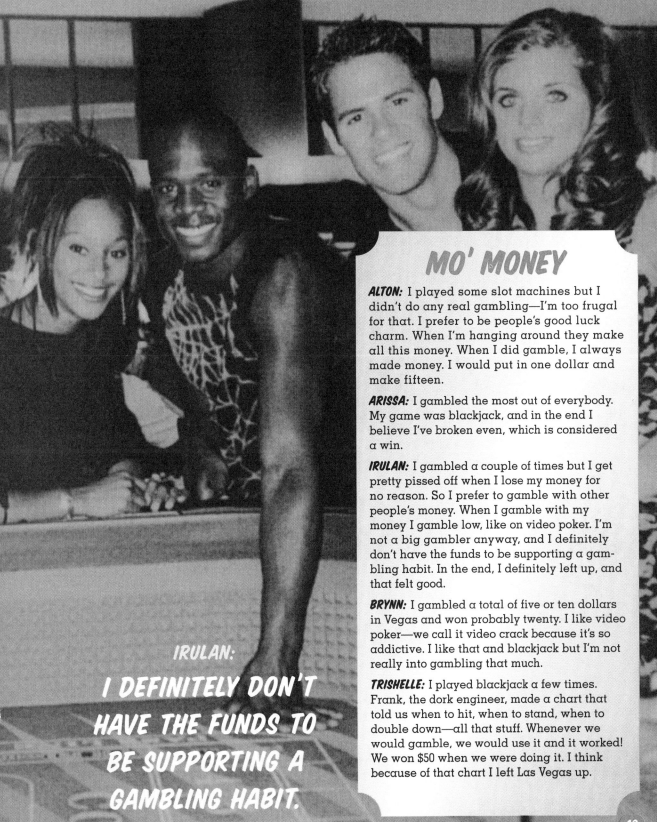

MO' MONEY

ALTON: I played some slot machines but I didn't do any real gambling—I'm too frugal for that. I prefer to be people's good luck charm. When I'm hanging around they make all this money. When I did gamble, I always made money. I would put in one dollar and make fifteen.

ARISSA: I gambled the most out of everybody. My game was blackjack, and in the end I believe I've broken even, which is considered a win.

IRULAN: I gambled a couple of times but I get pretty pissed off when I lose my money for no reason. So I prefer to gamble with other people's money. When I gamble with my money I gamble low, like on video poker. I'm not a big gambler anyway, and I definitely don't have the funds to be supporting a gambling habit. In the end, I definitely left up, and that felt good.

BRYNN: I gambled a total of five or ten dollars in Vegas and won probably twenty. I like video poker—we call it video crack because it's so addictive. I like that and blackjack but I'm not really into gambling that much.

TRISHELLE: I played blackjack a few times. Frank, the dork engineer, made a chart that told us when to hit, when to stand, when to double down—all that stuff. Whenever we would gamble, we would use it and it worked! We won $50 when we were doing it. I think because of that chart I left Las Vegas up.

IRULAN:

I DEFINITELY DON'T HAVE THE FUNDS TO BE SUPPORTING A GAMBLING HABIT.

NO MONEY

STEVEN: I played blackjack but I'm not very good at it. I would get up really high and then bet it all and lose everything in one hand. I left Las Vegas down about $200.

FRANK: The first two months in Vegas I didn't gamble at all. Then I said to myself, what the hell am I doing? I'm in Vegas and I should be losing a little bit of money! I went on the Internet and printed out the best possible way to make your money last. It took the gambling out of gambling, basically. I printed it and laminated it and the first day I used it I won $50. So I thought, hell, I could do this all the time. I have no problem with free money! The next two weeks I lost $280. That was the end of my gambling stint.

FRANK:

HELL, I COULD DO THIS ALL THE TIME.

Gluttony

ALTON: We partied way too hard in Vegas. I didn't party at all at home—I really didn't drink and I didn't smoke cigarettes. Sometimes I feel like all I did in Vegas was drink and smoke! Smoking and alcohol go hand in hand.

IRULAN: I've definitely done a lot more drinking and partying in Vegas than at home, but I wanted to do it and I had a great time.

FRANK: I did not expect the amount of partying that went on. I really didn't. I thought that we'd probably party the first few days and then only on weekends. Wrong. My roommates went out every single night and I kept up with them for about a month, month and a half. I thought I was going to die.

STEVEN: There was no reason not to go out while we were in Vegas because how lame are you going to be not to go downstairs? We had three different venues we could go to: Skin at the pool, Rain downstairs, and Ghostbar upstairs. It was exhausting and draining but it was all in good fun.

ARISSA: I had a good time in Vegas—I think we all did. It was fun to see my roommates drunk, too—everything gets exaggerated with alcohol. Frank gets a thousand times louder when he's drunk. He's already loud, so when he was drunk he was always shattering glass somewhere. Steven is a lightweight, so he was stupidly drunk a lot of times. It was fun.

TRISHELLE: We were drinking so much. I know I'm going to watch the episodes and say "Oh my God! I can't believe I did that!" But in the long run, it's going to help me. I'm not going to drink that much again. Ever!

BRYNN: There were a bunch of times when the night before was a little bit foggy… which is a shame because I wanted to remember a lot of it. A lot of the times when I was drinking, the days flew by so fast and I didn't really get a chance to absorb everything and that kind of sucks. That said, I'm still going to miss the fun. It was one big party and I don't think there's any kind of party that can top a Las Vegas party. To me, all parties from now on will just pale in comparison.

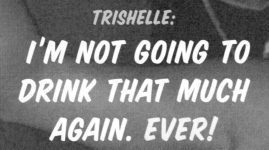

TRISHELLE:

I'M NOT GOING TO DRINK THAT MUCH AGAIN. EVER!

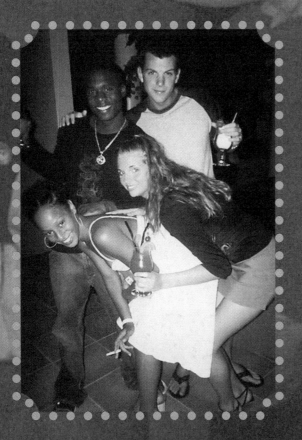

DR. LAURA KORKOIAN (CLINICAL PSYCHOLOGIST) LEAD DIRECTOR: [Dr. Korkoian joined Bunim/Murray Productions's casting department for *The Real World—Hawaii* and has moved up through the ranks to become a lead director for *The Real World*.] The cast was no different, in my opinion, than anyone who partied in college. People could say, oh, they drank a lot, but do they know what it's like living in a casino where there's alcohol 24 hours a day? Thank God, there was never a point when we were concerned about their physical health. We have a policy where they cannot drink and drive. Frank was always the designated driver. And even when they all went out partying, they just took a cab. They were so good about respecting that one rule.

Pride

TRISHELLE: I am proud of dealing with my mother's death while I was in Las Vegas. I had never talked about it and in Las Vegas I talked about it a lot. That helped me some-what—with my anxiety and closure issues especially.

ALTON: I'm just proud that I was myself and that I opened up and that I was just real. Whether I was right or wrong, I reacted in situations the way I normally would have reacted.

ARISSA: I'm proud that we all honestly got along.

FRANK: I was most proud of getting accepted to Cornell for grad school because it was years of work rewarded. It takes a lot of time to apply—it's like a part-time job. Though it looks like I'll end up going elsewhere it was something I was really hunting for and when I found out I got in I was so psyched.

STEVEN: I'm most proud of my friendships with Frank and Arissa. Those are two relationships that grew in such a good way.

BRYNN: I'm proud of finishing the *Real World*. I'm proud of myself for sticking it out and being really open with my feelings and accomplishing something that I set out to do. There were so many times I wanted to back out and go home, so completing it made me proud that I could do it.

IRULAN: I'm just proud I survived.

IRULAN:

I'M JUST PROUD I SURVIVED.

ALTON:

I'M JUST PROUD THAT I WAS MYSELF AND THAT I OPENED UP AND THAT I WAS JUST REAL.

Envy

ALTON: Irulan is one of the first girls I really got jealous over. I'm not a jealous or clingy type person. But if I saw her talking to another guy it would make my stomach twist all up in knots and I would have to leave the room.

IRULAN: It was very hard for me when Alton was out there talking to girls in front of my face. That is not something that I'm used to because I was never with a guy that needed to do things like that. I'm usually not a jealous person, but it was really challenging on my ego.

BRYNN: When I first came here I was very jealous of my roommates. They're all beautiful with great bodies. I just didn't feel like I measured up to them and I felt like the one girl who doesn't really mix. It sucked that I felt that way because my roommates are

amazing. It made me realize that I am me and I am my look and guys like me for me and Trishelle, Irulan, and Arissa for who they are. It's all a matter of who you are and your personal style.

STEVEN: I'm jealous that Frank didn't have to do that embarrassing performance in Australia! That bastard got out of it!

FRANK: I don't think I was ever jealous.... I definitely was *not* jealous of hooking up with a roommate, that's for sure.

TRISHELLE: I sometimes would get jealous if Steven was talking to other girls, but I was more so jealous when girls would talk to Frank! I'm a little overprotective of him.

ARISSA: I definitely envied some of the other roommates' financial security.

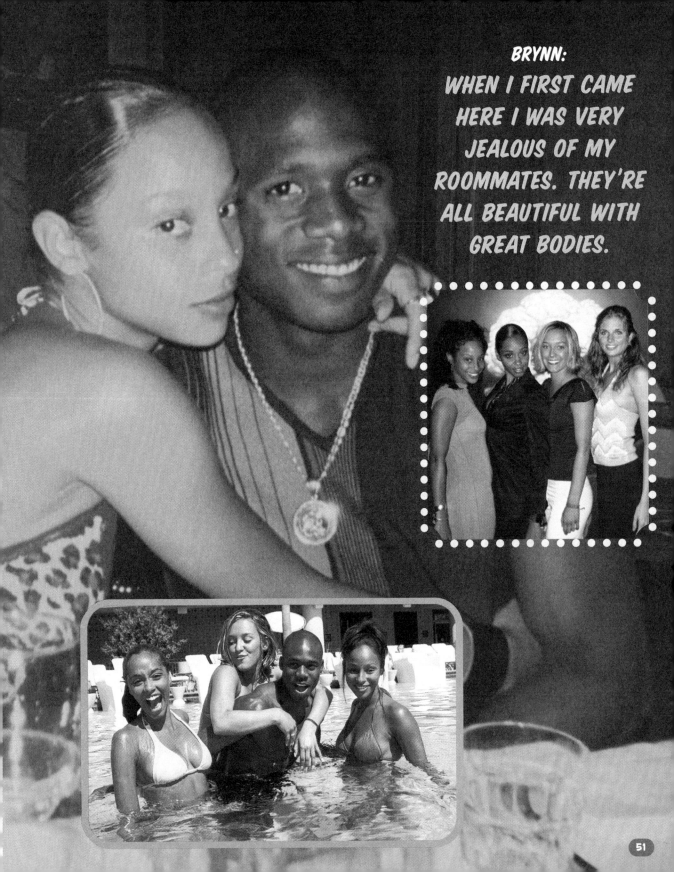

BRYNN:
WHEN I FIRST CAME HERE I WAS VERY JEALOUS OF MY ROOMMATES. THEY'RE ALL BEAUTIFUL WITH GREAT BODIES.

51

Anger

IRULAN: I think my angriest moment goes back to the whole Alton situation. There was a day when I had been hearing all of this stuff about him from other people in the house and I felt that my friendship with him was being betrayed. I felt like he was lying to me about things. I didn't know what was true, what wasn't, or what to believe. So we just had it out. I screamed at him. I told him to never look at me again, and that I hated him. Obviously that was just my hurt feelings talking and coming out in anger.

ALTON: My angriest moment was when I found out that Melissa, my ex-girlfriend, had cheated on me. I mean, I knew she cheated but I didn't know with who. Also, I'd get angry with the cameras sometimes.

FRANK: One of the biggest fights I ever had was with Alton. He had been drinking and getting on my nerves and being what I felt was very disrespectful to me. That was the worst thing I've gone through since I've been here because I didn't come here for that. I didn't come here to yell at my roommates or tell them they're bad people. I told him I didn't like who he was and that he was being a real dick, and I pretty much said that I was not interested in being his friend. He was like, fine. It was a pretty high-intensity conversation and probably the worst argument I've ever really been in.

ARISSA: I was probably the most confrontational in the house and the dynamics of the group changed constantly, and I probably had a lot to do with killing a lot of good vibes. We reacted off each other's emotions. Overall, this experience has helped me manage my anger better. It helped me become aware of when I get to the point of no return.

JUMPING TO CONCLUSIONS

TRISHELLE: I was really, really bitter whenever Irulan and Arissa were like, "We think you're bulimic." I think that was unfair, because they didn't know me, and no one really knew me right away, and of course I didn't take the time to explain but I don't think you should have to explain things to people right away. They shouldn't have made those assumptions about me. I know we all make snap judgments about people but that was something I was angry about for a long time afterwards.

IRULAN: I am very sensitive to eating disorders because I suffered from one for two years and I know how miserable it is and how secretive it is. I am better now, but I felt I wasn't ready to be around it and live with somebody who wasn't upfront about it.

But I think we were jumping to conclusions about Trishelle. I reacted very poorly to the situation because of my own personal baggage. Even if she did have an eating disorder it would be her business to bring it to the table. It wasn't our business to force her to. And I don't even think that was the case. I don't think that she has an eating disorder and it's her business either way.

ARISSA: I once watched somebody with an eating disorder wither away to nothing and die, and I've experienced it head-on over and over again with other people in my life, so I just wanted to help Trishelle if it was a problem. Now I feel bad, because I don't want that stigma to be attached to her.

BRYNN: I don't know if we blatantly said, "You have an eating disorder." The topic came up and we voiced some concern and it was about us watching out for each other. I don't think there was really a problem there, but I think she was having some medical issues.

ARISSA:
I PROBABLY HAD A LOT TO DO WITH KILLING A LOT OF GOOD VIBES.

BRYNN:

IT WAS PROBABLY ONE OF MY MOST ANGRY MOMENTS I'VE EVER HAD IN MY WHOLE ENTIRE LIFE.

ALL FORKIN' HELL BREAKS LOOSE!

BRYNN: Steven and I got into it a couple of times. We got into a pretty big fight during the second week when I threw a fork at him. The whole situation was just dumb, and the verbal abuse and the things that were said made me really angry. It was probably one of my most angry moments I've ever had in my whole entire life.

Steven could have made me leave the house but he let me stay because I think he saw a lot of himself in me. He's a few years older than me but he says that there are a lot of similarities in our lives. And he's changed a lot, so he made it clear that if he was sending me home he wouldn't be giving himself a second chance. And I think he did know that I wasn't trying to hurt him at all.

STEVEN: I didn't think I was going to be physically injured, but there was a very real chance of Brynn going crazy again. And I don't stand for any kind of violence like that, especially between men and women.

I talked to Brynn and it wasn't like she asked to stay or apologized or anything because I don't think she cared either way. I think it came down to that she was a screwed-up kid. And before I met my ex-wife, I was a screwed-up kid. Brynn was basically me. So I looked at it like giving the old Steven a second chance.

ALTON: There was tension between Brynn and Steven for some time. When I saw that Brynn threw the fork at Steven, I was like, "Damn! This girl's got a lot of heart!" And Steven was saying some nasty things to her so they both were at fault. I didn't want Brynn to leave but I also thought if it were me I would have probably been asked to leave because I'm a

man and I'm black. I really wanted it to be fair for everyone in the house so part of me did want to see her go home on principle alone. In the end, Brynn was one of my closest roommates and I'm glad she stayed and I had the privilege of getting to know her.

IRULAN: It's never okay to physically abuse somebody and I feel very strongly about that. But I think that verbal abuse is just as powerful. So, they were both wrong in the situation.

ARISSA: I knew it was going to happen. Four days before that I said, "This shit is going to blow up and I don't want a part of it!"

FRANK: Steven's reasoning for wanting to throw Brynn out was that she could have injured him, and that if she did it again he would end up having to defend himself and he might hit her by accident. I thought that was totally ridiculous. I personally think that if you don't want to hit a girl, you won't hit a girl. I mean, Brynn was totally wrong—I couldn't believe she threw a fork at him. That was dumb of her. But I also disagreed with Steven for his actions after it.

TRISHELLE: In the beginning whenever Brynn fought with Steven she told me it was because Steven was disrespecting me, like she was sticking up for me. Then, Frank tells me Brynn was upset because Steven and I were together. Then, I was just like, I don't want to live with this girl. I was not down with the whole jealousy thing. The incident put pressure on our relationship in the beginning and that's why we didn't get along that well. But when it all came down to it, I was really happy that she ended up staying because I feel like she added a lot to the group and I feel like she and I got closer toward the end.

DR. LAURA KORKOIAN: What a night that was! Tracy Chaplin and I were all excited because we were going to barbecue some steaks and relax and watch *The Real World—Road Rules Challenge*. We had just sat down and the phone rings and it was a call saying that there had been an incident where Brynn had thrown a fork at Steven and he wanted Brynn gone. That was the end of the steak. I think I left the Palms at 4 A.M. That was probably one of the most dramatic moments of the season.

STEVEN:

BRYNN WAS BASICALLY ME. SO I LOOKED AT IT LIKE GIVING THE OLD STEVEN A SECOND CHANCE.

ARISSA:
I PERSONALLY DON'T LIKE BEING CALLED A BITCH.

"BLACK BITCH"

FRANK: I was on the phone and I knew Arissa was standing right in front of me and I teased her and said that she was the "black bitch" in the house. At that point, I thought I was close enough with Arissa to tease her like that. It was taken as something insulting and derogatory and I was hurt by the entire situation. But I completely sympathize with how Arissa felt about it. And I'm glad that she talked to me about it in the mature way that she did.

ARISSA: Nobody really knew anybody's sense of humor yet, and I got affected by Frank's comment. I personally don't like being called a bitch. And it put a flag up in my head, like, oh my god, who am I living with? But it was resolved very amicably and I don't want anybody to think Frank is a racist or that he disrespects women.

REAL WORLD RAGE

ARISSA: I was fed up with the people on the outside who were giving me a lot of grief and flack for being on *The Real World.* I took my anger out on somebody toward the end because they were being really ignorant and rude. I ended up walking away from that with a sprained ankle.

Alcohol plays a very big role in those altercations. The most I got into were when people were drunk, including myself.

Once we were at this café and these idiots came and sat behind me and Brynn. Brynn was talking about her anxiety attacks, and this guy went behind Brynn's back and screamed so loud, we all jumped, and he walked away laughing. I was so mad I was shaking and Brynn was freaked out.

I went to the parking lot to smoke a cigarette and lo and behold there's that a**hole, and he comes up to me and asks, "Are you on *The Real World*?" I responded, "Who f****** raised you? What kind of a person does s**t like that? Why would you ever do that to somebody?" And he backed me up against the wall and said that if I couldn't handle it I shouldn't be on the *The Real World.* I told him to back up and he didn't listen. I told him twice to back up and two times he didn't listen. So I flicked my cigarette at him, it hit him, he backed up and when I was walking away he kicked me in the back of my leg.

IRULAN: How I dealt with people harassing us depended on how much alcohol was in my system. I think that if you have a sober mind it's very easy to keep a level head and be like, oh they're just drunk. But when you're out in a nightclub drinking and you're just trying to have a good time and people are screaming hateful things at you it gets really aggravating. Personally, if I saw somebody in a nightclub and they had a camera crew I would not take it upon myself to go over and ask them what they're doing and demand that they tell me what they're a part of. That's ridiculous.

ALTON: Sometimes people would get physical and push us. Usually I would push them back off me. I think they're just jealous of this cool experience.

ARISSA:

WHO F****** RAISED YOU?

BRYNN: My roommates seemed to get a lot more flack than I did. I did experience it a few times when we'd just be walking through the casino and people would say "*Real World* sucks." Or we'd be sitting down to dinner and people would come and sit down next to us and stare at us or say, "I'll have a *Real World* cheeseburger, *Real World* fries, and a *Real World* shake." Or, "The camera adds ten pounds, don't they know that?" while we're eating. I was involved in one fight where I might have pushed somebody and that was the second week, and after that I realized that these people are so stupid. They're not going to put that on camera. It sort of sucked that my roommates took it to that level where they actually got in a fight and threw stuff and said stuff back to them.

FRANK: The girls got it the worst. They have had cups thrown at them, gum thrown in their hair—and mainly it's other girls that do it. I was always like, "What did you do to that girl?" And my roommates would say they had never seen that girl in their lives. I think it's just drunk people. They get drunk and see a bunch of 21- to-24-year-olds having the time of their lives and they think we don't appreciate the experience—like we're a bunch of brats or something.

TRISHELLE: I think that some people act very strange when they see a camera. I don't know if they were raised in a barn or what but they just don't know how to act around them. One time we were at the Sunrise Café in the hotel, and this guy was being a complete jerkoff. He was mocking us and imitating us, and he had this sign and everything, but he requested to sit by us. What's up with that?

I would get mad but I would never physically handle anyone. One time I was in Rain and there was this girl. I don't know if she mistook me for someone else or what, but I had just moved to Vegas and I didn't know her and she didn't know me. She saw the camera and came over and said, "You're a whore," and then she threw a piece of ice and hit me on the cheek. I flinched and the guy I was with said, "Aren't you going to do something?" And I was like, "What do you want me to do, pull her hair?"

STEVEN: Whether you mock it or you love it, everyone wants to be a part of *The Real World*. Brynn said the funniest thing to one guy once. She said, "Did you see the episode with the guy in the background yelling at the cameras?" And this guy said, "No." And she said, "Exactly!"

ALTON:
I THINK THEY'RE JUST JEALOUS OF THIS COOL EXPERIENCE.

FRANK:

THE GIRLS GOT IT THE WORST. THEY HAVE HAD CUPS THROWN AT THEM, GUM THROWN IN THEIR HAIR— AND MAINLY IT'S OTHER GIRLS THAT DO IT.

Sloth

HARDLY WORKING

IRULAN: The promoting/performing sucked. Rain is a really nice venue, and I've worked in clubs before, but I felt a little standoffish passing out flyers and striking up conversations with random men to invite them to this club. Also, I need a little more structure than just, "Log in twenty hours this week." It was very loose. So it was very easy for me to slack off because there wasn't a clear beginning and a clear end.

With the performances there was more structure where we knew we had X amount of days to get it together. We'd have to come up with a theme, we'd have to get costumes and rehearse. But a lot of the themes we ended up with sounded good on paper but not necessarily for us to have to act out or bring to life.

FRANK: The first nightclub I ever went to was Rain. I was a little scared but interested in it at the same time. At first I liked working there but as the months rolled by I realized that I am not a promoter. I really don't care to go out and talk to thousands of people I don't know. But it was a job that was thrown in our laps and we had to do it. I got to a point where I wanted to quit but I couldn't. I guess I'm just too shy for promoting.

I MEAN, RENT WAS PAID FOR—AND THAT KIND OF TURNED ME OFF AND TOOK THE FIRE OUT FOR ME.

ALTON: When we first got the job I was the one who was really excited, but then we didn't have as much control as they led us to believe. It was weird, working for something, but knowing that you really didn't need to work—I mean, rent was paid for—and that kind of turned me off and took the fire out for me.

TRISHELLE: I didn't think the promoting job was that bad at all. There were a few times that I wanted to take the box of flyers and throw them up in the middle of the street but I'm a people person so it was okay for me to approach people and talk to them.

The thing I did like was working for *Stuff Magazine*. None of my roommates mentioned it because no one did anything for it except me and Steven. We had to find and interview women for the "Powder Room"—a segment they have in the magazine about sex and relationships. We made up a questionnaire, found five really nice, really good-looking girls and interviewed them. We also assisted the photographer with the shoot. I worked from 11 in the morning until 2 in the morning one day but I loved it, I just loved it.

It was funny. You have the picture of these women in Las Vegas who are cocktail waitresses and when we were asking them these sexual questions they were very, very reserved. A lot of them were like, "I'm engaged." Or "I have children and this pays."

They make a lot of money and they work very hard and put up with a lot of shit and I respect that.

BRYNN: I hated our job as promoters. I wanted to quit the second week. I didn't feel comfortable going up to people—especially with a camera following me—and saying, "Come to our club."

ARISSA: In the beginning it was a great job, then what happened was it got to the point where we had to embarrass ourselves constantly. We were supposed to perform all types of shit, and it just got to the point where I was like, I hate this, I don't want to be here, I don't ever want to do this again. I wanted to quit at least three times a week.

STEVEN: A couple of things made it all go wrong. No one particularly cared for our boss, and we had no set hours. When you combine that with 24-hour drinking it really drives toward a less responsible work ethic. Back home, I pay for everything. If I don't work, I don't live. Here it was a totally different story. We really didn't care about it and we were putting on these really embarrassing shows and they kept getting worse and worse and worse. I think somebody was sitting back saying, "I'm going to make them do this and that," and laughing at us. It was bad, just plain bad.

MARC PORTUGAL:

VEGAS KICKED THEIR ASSES.

MARC PORTUGAL, DIRECTOR OF MARKET-ING, NINE GROUP: I think the challenge they failed to overcome was Las Vegas. When they were up until 6–7 in the morning and they were asked to go promote during the day or show up for a rehearsal—they didn't like that. Sometimes they didn't even show up at all.

In general their job performance as a group was above average. But if this wasn't in the context of an MTV pro-duction their performance would have been horrible. No employer would ever tolerate a group of people tasked with something and then going to lay out at the pool. No employer would ever tolerate when you go into a nightclub to talk up a party that we had and when you walk in they are all wasted drinking champagne. No employer would ever tolerate them being scheduled for rehearsal and them sleeping through it. But this was all linked into the fact that Vegas kicked their asses.

BRYNN: Marc Portugal means well. There were times when I thought higher of him than the others.

ARISSA: Marc is a lot more intelligent than I give him credit for. At times I felt he gave me really, really good advice.

ALTON: We had our ups and downs with Marc, professionally and as friends, but he's cool, if a little hard to work with.

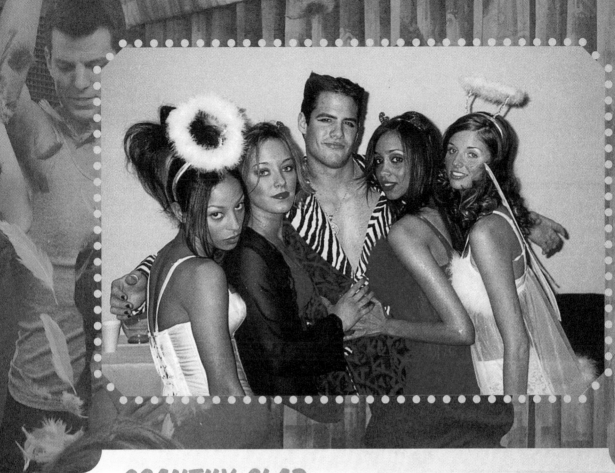

SCANTILY CLAD

IRULAN: We had one party where the theme was "Good to Be Bad" and we dressed up as angels and devils. We went to Frederick's of Hollywood and got costumes. I walked around in a nightclub in garters and stockings, a bustier, underwear, heels, and all this makeup and hair and a feather boa. And Thursday night when we first arrived wasn't a very big night.

So we were walking around in an empty club in these ridiculous getups and people didn't understand. Granted, we came up with these ideas. I guess we envisioned them differently, or didn't think enough about them. But there were certain things where you just end up feeling like a fool. At the end of the night you feel, not exploited, but just dirty. And $10 an hour is certainly not worth my pride and dignity.

ARISSA: I don't know what it is with Las

IRULAN:
$10 AN HOUR IS CERTAINLY NOT WORTH MY PRIDE AND DIGNITY.

Vegans, but we threw a lot of theme parties and they just didn't get it. There was a "Good to Be Bad" theme party and there are Good/Bad signs everywhere and I'm walking around dressed up like a devil in something from Frederick's of Hollywood, which I never want to wear again as long as I live, and people were like, "Why are you dressed like that?"

BRYNN: I did not like wearing lingerie at a club. I know we all agreed on that and picked out our outfits together. But I don't think we were aware of the situation and how it would be. We thought it would be fun but when we actually put on the lingerie we thought, *Whoa! Nobody knows us and there's these cameras*

around. And the reality set in. I didn't like it but I'll admit it was kind of our fault.

JEAN NEDEL, ENTERTAINMENT COORDINATOR, RAIN NIGHTCLUB: This is very funny to me. The group wrote a proposal, which was very good, very sexy and steamy. Keep in mind, *they* wrote the proposal. We went to Frederick's of Hollywood. *They* picked the costumes. I had nothing to say, because it was their project. At the time of the performance, all of a sudden, they didn't like it. "I feel uncomfortable," they said. I think they realized, maybe their parents were going to see that, and it seemed to always sink in the day of the show!

JEAN NEDEL:

I THINK THEY REALIZED, MAYBE THEIR PARENTS WERE GOING TO SEE THAT, AND IT SEEMED TO ALWAYS SINK IN THE DAY OF THE SHOW!

SHOW ME THE MONEY!

IRULAN: We were not paid enough for what it was we were doing because some weeks we were clocking way more than twenty hours and in addition performing and rehearsing and all of that stuff. I think we could have been paid more.

ALTON: I think we were paid enough. You can't expect to get paid a huge salary and not really work. We only half-worked, if anything, a quarter of the time.

FRANK: Toward the end, we didn't deserve a penny. They gave us enough money to get by, but toward the end, everyone wanted to quit and we all got real lazy about work.

ARISSA: Hell, no, we did not get paid enough! I was broke. I had no dough. And I hated it. I was miserable half the time because I couldn't even buy a pack of cigarettes.

STEVEN: I think we were unfairly compensated because we weren't doing any work and we still got paid. That's unfair! I don't think I did anything the last month.

TRISHELLE: We were not paid enough. You cannot put a price on dignity.

BRYNN: Money was really tight in the house but for the job we were doing we couldn't ask for more because half the time we didn't even work. We probably didn't deserve as much as we got.

FRANK:

TOWARD THE END, WE DIDN'T DESERVE A PENNY.

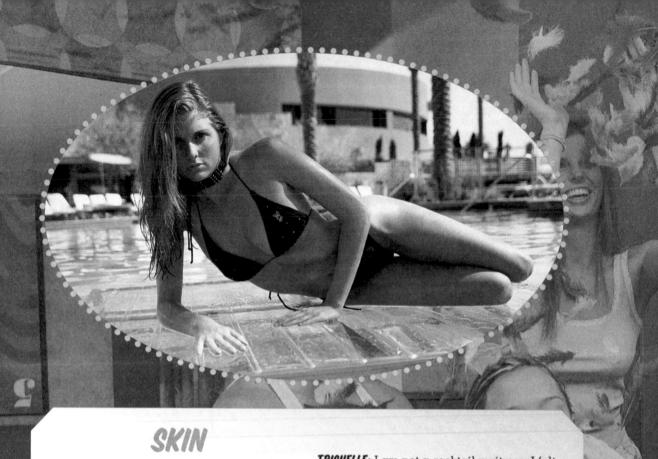

SKIN

IRULAN: Cocktailing at Skin would have been a great job to have all along. But I think it was too much to deal with having a second job so late in the season. It was hard to get up at 8 in the morning and go downstairs in the hot sun. It's daytime, you're outdoors, you're at a pool, and you're walking around in a bikini. You're half naked and bending over with a tray and serving people in this incredibly hot sun. And they don't pool tips. So there would be girls who were making $900 a shift working in the blackjack pit area and others who were making $50–$60. And everybody was getting the same stations for every shift. I didn't want to spend my time working like that for an extra fifty bucks.

ARISSA: I tried the cocktail waitress thing at the pool and it was the hardest thing I have ever had to do in my life. I couldn't hold a cocktail tray. And I never knew it was so windy in Vegas. The drinks would be blowing over and spilling. I couldn't deal with it.

TRISHELLE: I am not a cocktail waitress. I felt so degraded wearing go-go boots, a little fringy skirt, and a cowboy hat walking around and serving drinks. People were disrespectful on top of that, like snapping their fingers at me and stuff. And my feet were killing me! So I quit after four days. Even for $250 for a couple of hours. It might seem like a lot but to me it's not enough.

STEVEN: Bartending was great fun and I made enough money to finish paying my bills until I got back home. I thought I did a good job at Skin—I'm actually a really hard worker.

GINA BOCCADORO, MANAGER, SKIN: I'll admit the amount of work you have to do out in Skin is tough. You have to acclimate yourself to the heat and it's more work than I think anybody realizes. You're dealing with the elements and you're dealing with food and beverage and it's very busy and it's tough.

YOU GO-GO GIRL

BRYNN: Go-go dancing is something that I came to Vegas wanting to do and I never thought I would get the opportunity to do it. I had a great time doing something that I love to do—dancing—and getting paid a really good amount of money. But it was also really hard work. It was hard when my roommates were all having a good time and I was working. But I put my full heart and energy into it and I'm glad I did it. It was my extra money.

JEAN NEDEL: Brynn had to audition to become a go-go dancer and believe me, there was no favoritism, because regardless, we are running a business and she has to look good and we're not going to hire you just because you're on TV. I think she did a great job.

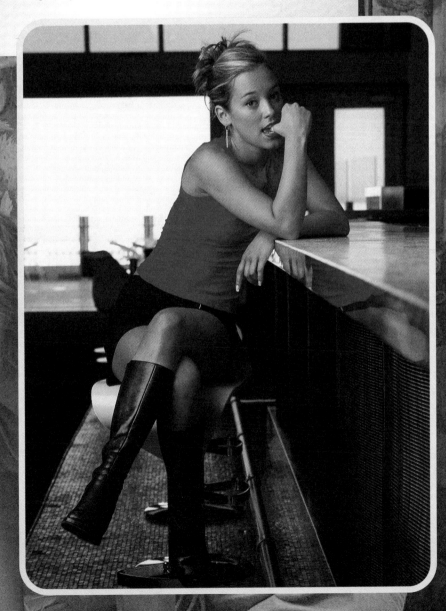

TEAM BUILDING

ALTON: Awesome Ann's course was a really great experience for me because it helped me realize that I have all the tools it takes to build a positive foundation for myself and my family. It also helped me to see some of my unconscious negative programming. For example, I realized that laughing at racial jokes sends the message that making a racial joke is okay and that's not the case.

FRANK: I didn't get a single thing from those team building exercises. We did trust falls and all those things—it was so fifth grade—completely elementary and so stupid.

IRULAN: I went into the team building exercises assuming that I wouldn't get very much out of it and then it totally changed. At the time Steven and I were having challenges in our relationship and that was basically when I realized that Steven didn't want to have anything to do with me as a person. And that's hard to take. Even if you're not the best of friends, you want to be liked. It made me realize that the way I communicate with people is important.

ARISSA: Going through the team exercises was one of the turning points for me. It taught me to learn to accept people as they are and not to judge.

We did a "lifeboat" exercise where everybody's going to die and there's only room for one person in the lifeboat and we had to pick who should live. That was so hard.

TRISHELLE: The team exercises taught me a lot about myself and my self-worth. I think that Arissa gained the most out of it, but I learned a lot from it also. The whole experience brought us closer together as a team.

STEVEN: I really didn't get anything out of the team training, but it had a big effect on Brynn. I guess as long as it affected somebody it was worthwhile.

BRYNN: There was a part where we had to take turns going out and writing down all of the other names for a woman, or all of the other names for African Americans. When we read what everyone had written, it was very powerful and I think it impacted everyone a lot.

ALTON:

I REALIZED THAT LAUGHING AT RACIAL JOKES SENDS THE MESSAGE THAT MAKING A RACIAL JOKE IS OK.

HARDLY HOUSEKEEPING

FRANK: We were incredibly sloppy. Brynn was the only one who was adamant about cleaning the place up. She'd come home and even if she was one of the ones who was messing it up she was always disgusted by the house. We were like, "Yeah, you're right, the place is gross, but it would probably be pretty difficult to clean it up now." At first, I thought, my roommates are going to kill me because I am a disgusting slob. But when I arrived I found that Alton and Steve were just as disgusting. And I never knew how to do laundry before, but Arissa was kind enough to teach me how.

The grossest thing about the house in my opinion was that hot tub. I never got in that damn thing—too many things happened in there that were just...unhygienic.

TRISHELLE: Everybody was messy. It was so hard to clean, though, with seven people. One day, I took the whole day to clean—I cleaned everything spotless—and the next day it was dirty again.

Arissa was very messy. She left her stuff around everywhere but she wasn't dirty or filthy or anything.

The grossest thing about the suite was the boys' room, for sure. It stunk. You would open the curtains and it was a wall of stench in there, especially around Frank's bed.

STEVEN: As far as my room was concerned, I was very sloppy. But otherwise, I didn't do anything in the house. I always ate out and I showered at the spa.

Girls are really dirty in the bathroom. I don't see a need to have a waste bucket near the toilet—guys don't throw anything in there. But the girls would have them filled up in thirty minutes. But one good thing was that I got to learn about toxic shock syndrome because I got to read that box so often. I learned that I don't want TSS. That's bad news.

FRANK:

TOO MANY THINGS HAPPENED IN THERE THAT WERE JUST...UNHYGIENIC.

ALTON: We were definitely a sloppy group. We would party so hard and come in around 8 A.M., and pull out all the food in a drunken stupor and leave it there.

I think Arissa was the sloppiest, though. Her stuff was just everywhere. Arissa's pants, her shoes, her cigarettes, hair stuff, license, passport, jacket—everything was everywhere.

IRULAN: We lived in filth, absolute filth. The showers got especially disgusting. The bath mat right outside of the showers would collect all of this water because the drain was there. After a few days it would stink. Then there were the dishes, and the food crusted on the table. It was all just disgusting.

Trishelle and Brynn probably kept their room the neatest out of all three. I shared a room with Arissa and I feel like she was real messy, but I was also messy. None of us are dirty people, and I think that seven people accumulating dishes and everything—it just can't help but become a mess.

BRYNN: I am normally a messy person but I want my kitchen and bathroom clean. When the house needed to be cleaned, I would clean it up.

Arissa was the messiest. She had stuff lying around everywhere. Alton was messy, too, and I think he's used to people picking up after him.

Those showers were the grossest. The rug in the shower area would get wet and stink.

BRYNN:

THOSE SHOWERS WERE THE GROSSEST.

THIS IS HOW YOU FLUSH A TOILET, YOU NASTY BASTARDS, IT'S NOT THAT HARD.

ARISSA: It's news to me, but according to everybody else I was allegedly the messiest. I find that completely ironic since I'm the only one who really tried to clean up. I mean, my room is my room. And if I want to sleep on a pile of clothes that's my own personal business.

I think everybody else was sloppier than me. We started with chores, and that didn't work. Then we assigned chores to the guys because we thought they were the messy ones. What ended up happening was that we would clean the house and then go out, and every night, without fail, one of us would come back with the drunk hungries and we'd make or order all types of food, eat it, and leave that and liquor everywhere. The house would be destroyed within six hours of cleaning it.

The grossest thing was the nasty bastards who would not flush the toilet. I would flip the f*** out! Whoever it was would never admit to it. I would write directions and tape it to the bathroom door: this is how you flush a toilet, you nasty bastards, it's not that hard.

71

Lust

SEX AND SIN CITY

Alton & Irulan

IRULAN: In casting, they asked, me: "What's your dream man look like?" And I said, "I don't have a dream man. I have a lot of different tastes." And they said, "Just describe one person you would like to meet." Well, my boyfriend Gabe is white and Jewish, and the last few boyfriends I've had have been white. So I said, on a whim, "I think I would like a beautiful, strong, black, bald-headed muscly man." So, on the first day, when Alton walked through the door I knew I was set up.

I looked at it as, hey, I'm happy, I have a boyfriend. And Alton definitely lived it up in Vegas in terms of the women and the night-clubs. So I didn't see him in a romantic way in the beginning and we were friends.

One night, Alton brought home a friend who was too drunk to drive. I pitched a tent in the living room because Arissa had her boyfriend in town and Brynn had her boyfriend in town, and Trishelle slept in the boys' room, so I had pitched a tent to have my own room and to have a place to sleep. So, Alton comes knocking on the tent and tells me his friend is going to sleep over and would I feel uncomfortable if he was on the couch? And then he decides to put him in his bed and come in the tent with me....

There was something about that night, something about the energy, about everything that was leading up to this, that felt so right. That's the moment when things changed for us.

ALTON: I did not think I would end up with one of the roommates. Steven actually said something to me on the first day, and I was like, "Dude, no way!" I just didn't see it and I didn't want it either. I was like, "You guys can mingle amongst yourselves but I'll just get someone and bring her home!" It's a lot easier that way. They come over, chill for a while, and *then they go home.* You don't have to sit and stare at them all the next day.

The day after Irulan's birthday we had a conversation about me bringing women home. She said if I want to be with other girls in Vegas, then be with them. If I wanted to be with her, than I had to be with only her. I chose to be with Irulan.

Talks—or arguments—like that brought us closer together. We were expressing our doubt honestly, as well as our anger and frustration. It let us know we can talk to each other. Now I definitely see Irulan and me together, no matter what, at least as friends. It's definitely not over—it's just starting for us.

DR. LAURA KORKOIAN: I saw the attraction between Alton and Irulan from day one. What I loved about them was there was a real tenderness there that was a joy to watch, some real romance.

ALTON:
**IT'S DEFINITELY NOT OVER—
IT'S JUST STARTING FOR US.**

Pillow Talk

BRYNN: I think that Irulan and Alton will last as friends and I think they both know that but I can't say that for sure because I don't know how they are both feeling. They are on the opposite ends of the U.S., however. Their friendship is probably stronger than their romance, however, and I think that's what's important anyway in the long run.

TRISHELLE: I don't think Alton and Irulan are really going to happen. Honestly, I think me and Steven are closer.

ARISSA: Only time can tell on that one.

STEVEN: In the end, Irulan and Alton seemed to have a really nice relationship. They were always spending time together, just the two of them.

SUITE SEX

FRANK: I was not having sex on television. I am not a soft core porn star. Don't get me wrong—I have sex, just not when there are video cameras in the room. I didn't do anything like that the whole time I was there. I was very hard up, but...down the road I'm going to go out with some girl and really like her, and I would hate to put her through watching that on television.

IRULAN: I came to Vegas with a boyfriend so I wasn't anticipating having a lot of sex in the house. Sex is private business but we had three bedrooms with seven people. Sometimes it just happens and you gotta do what you gotta do.

ARISSA: My position on sex in the house was you should have as much sex as you want, but not in a common area that people constantly use. I walked into the shower one day and I found a condom wrapper in the shower. Nobody wants to see that.

ALTON: I expected my roommates to complain about sex in the house but I did warn them that I'm loud and sometimes obnoxious. We're all adults, though. We all pay the same amount of rent, which is nothing, so no one has any more claim to the house than anyone else. I tried to respect people but at the same time I was going to have only one experience so I was going to have as much fun and enjoyment as I could.

IRULAN: We definitely had a term for the lovely ladies that Alton would bring home—"Alton's random ho's"—or just straight up "bitches."

TRISHELLE: Alton brought in some skanky girls and the whole deal with him bringing girls in the shower and the hot tub was kind of disgusting but I saw it as him having fun and doing his own thing. But it made me mad whenever it started to interfere with and hurt Irulan. Like on the night of Irulan's birthday, Alton brought someone home, and Irulan was passed out and she didn't know about it. I was really mad about that.

IRULAN:
WE DEFINITELY HAD A TERM FOR THE LOVELY LADIES THAT ALTON WOULD BRING HOME— "ALTON'S RANDOM HO'S" —OR JUST STRAIGHT UP "BITCHES."

BRYNN: I was fine with sex in the house as long as I didn't have to hear it. I thought it was funny when people would bring in random ho's, but I guess living with six other people you shouldn't do that.

FRANK: The fifth day we were in the suite, Steven and Trishelle woke me up having sex and I got mad about that. As the season progressed they did it so much that I got used to it and I didn't even care. It was like watching someone washing his face or something.

STEVEN: It's Vegas. We were all in party mode and that's maybe why we trivialized sex so much. In Vegas that's totally acceptable.

DR. LAURA KORKOIAN: Though it's a documentary we are not making porn. It's all about establishing intimacy—a sweet kiss, or a tender caress—establishing that these two people are interested in one another, and then backing off.

Steven & Trishelle

STEVEN: Being with a roommate was good and bad for different reasons. If I had to do it again, it probably would have gone down in a similar way. If Trishelle walked into my bar at home, I would pick her out. She's gorgeous, and actually, I think out of my league. The thing that makes Trishelle not intimidating is that she's always smiling.

Trishelle has been a pretty good friend to me, and we're going to continue to be friends. I'm not the guy for her. They don't get any prettier than Trishelle but it just wasn't there for us.

TRISHELLE: I wouldn't recommend hooking up with a roommate to anyone. Luckily, me and Steven are two mature people and we didn't really fight that much, because it could have been bad. In other circumstances, I don't think I would have hooked up with him. He's not my type even though he's very good-looking and very nice. We're friends and we'll stay friends and that's the way it should be for us.

DR. LAURA KORKOIAN: Steven and Trishelle are two sexually charged, passionate people, who were attracted to one another and just wanted to have fun. Do I think they had feelings for one another? Absolutely. Their argument was that they were perfectly content not being boyfriend and girlfriend, but I do think there was an emotional attachment there that they ultimately didn't know how to define. I think when it comes to relationships they're both still trying to figure out what they want.

Pillow Talk

FRANK: Steven and Trishelle didn't grow into a couple when they were here and there's no way they're going to. I will let you kick me in the stomach if they grow into a couple.

BRYNN: I think that Steven and Trishelle have always been really good friends and have never really been anything more than that—and that's how they will remain.

ARISSA: Will Steven and Trishelle end up a couple? Hell, no!

FRANK:
I WILL LET YOU KICK ME IN THE STOMACH IF THEY GROW INTO A COUPLE.

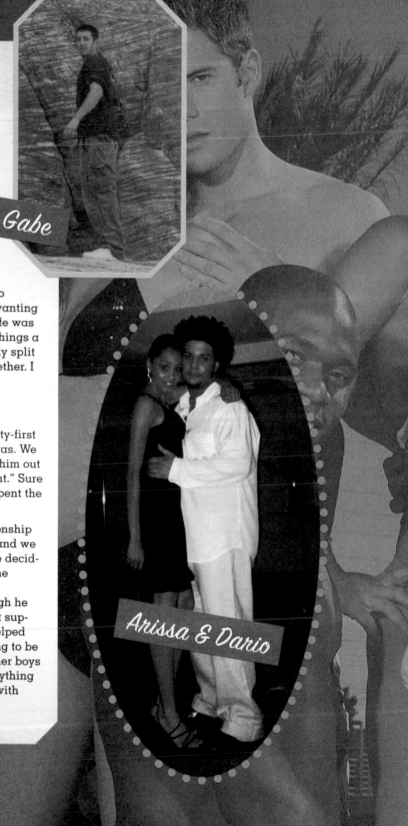

Irulan & Gabe

IRULAN: Gabe really didn't like Vegas, mainly because he felt very challenged by production. He's a private person and he didn't appreciate having all these other people involved in what was going on in our relationship. Because of that he felt very violated and self-conscious while I was used to the cameras and the whole situation.

Gabe

Arissa & Dario

ARISSA: I wish that Dario hadn't come to visit. It has nothing to do with me not wanting to see him, but once he saw what my life was like here, it changed him and it made things a lot harder to deal with. We are definitely split up and we will not be getting back together. I hope we'll be friends.

Brynn & Austin

BRYNN: I met Austin at my friend's twenty-first birthday party before I came to Las Vegas. We had walked into this bar and I pointed him out and said, "That guy will be mine tonight." Sure enough, we ended up talking and we spent the whole week together.

Austin and I kept up a phone relationship while I was here, and he came to visit and we felt something so much more and so we decided to take it to another level and become boyfriend and girlfriend.

He has been there for me even though he wasn't physically in Vegas. He's a great support and he listens to me and he has helped me through this whole process. It's going to be hard for me to watch myself kissing other boys when the show airs. Austin knows everything I've done here but for him to put faces with names—it's going to be a little much.

Arissa & Dario

Brynn & Austin

TRISHELLE:

IT WAS KIND OF LIKE WE RUBBED IT IN HIS FACE.

Frank & Trishelle & Steven

FRANK: The whole Trishelle thing at the beginning wasn't much of a conflict because it wasn't like she was my girlfriend, though I was definitely interested in her. I knew her for thirty hours before she and Steven hooked up. And it simply ended up that he hooked up with her and I didn't. It probably wasn't the best way to start off our friendship, but we got over it quickly.

TRISHELLE: I apologized to Frank because I really didn't want to hurt his feelings and I felt bad about Steven and me hooking up in front of him. I didn't feel bad about Steven and me hooking up—but it was kind of like we rubbed it in his face.

STEVEN: What I did was wrong. I had been drinking, but it was my fault, and it was just wrong. But Frank was bigger than that and he didn't hold a grudge and I hope that I've shown him that the friendship I have with him now is bigger than any girl.

RUB-A-DUB-DUB, THREE IN A TUB

BRYNN: The threesome in the bathtub with Steven and Trishelle was my most sinful *Real World* moment. But I'm perfectly fine with that. I did it, I had a good time, it was all fun and games to me. I know Trishelle had a hard time with it, so in that aspect I kind of feel bad.

TRISHELLE: The night of the whole threesome, I guess you could say I felt really uncomfortable about everything. But then I talked to Brynn the following day and she made me feel a lot better so I'm okay with it now. Alcohol played a huge factor in the whole situation.

STEVEN: I am totally fine with it. It was really fun. What problem would I have being with two beautiful women at the same time?

STEVEN:

WHAT PROBLEM WOULD I HAVE BEING WITH TWO BEAUTIFUL WOMEN AT THE SAME TIME?

WEDDING BELL BLUES

STEVEN: I liked being married. I keep saying I'll never get married again but I'm sure I will because I fall in love really easily. I don't think my ex-wife and I will get back together but she will be a good friend of mine for the rest of my life. I always want to be there for her.

TRISHELLE:

HONESTLY, I FELT IN MY HEART I WAS NOT PREGNANT.

PARENTHOOD?

ALTON: When Melissa told me she might be pregnant I was speechless. I had just gotten to Vegas and to say the least, it was all a little overwhelming. I just started thinking of how different my life would have to be. I know that I would have accepted the challenge, and with the help of family, Melissa and I would have been able to provide for the child. But I was just so scared because I knew I wasn't ready to be a dad. I was in over my head.

DR. LAURA KORKOIAN: We were fully able to explore Alton's fear about becoming a father and I think he handled it with real maturity. Of course he was upset and startled by the news, and realized that he would have to leave and go back to San Diego. It was so real and it's an issue young people face every day. We have never dealt with it on *The Real World*, except for Tami's abortion in the second season.

PARENTHOOD, PART 2

TRISHELLE: Honestly, I felt in my heart I was not pregnant, but I was afraid of what Steven might say, and that's why I didn't want Steven to know. Finally I just told him and he was very supportive.

STEVEN: I would really like to have a child. I'd rather not be having any right now because I'm still so young and I'm not financially secure, but if it had happened, I would have been totally okay with that.

DR. LAURA KORKOIAN: I think Trishelle was afraid of being judged, of having to tell her family, and of having to be a parent with a man that she was not interested in marrying or seriously being with. It was so hard for them because they weren't a couple and here they were being confronted with this situation. Even when you are in a committed relationship it is a hard decision—especially when you're young.

GUYS

BRYNN: The guys in Vegas, surprisingly, are not that hot. Every now and then you'll see a really good-looking guy, but they all tend to be about getting down your pants. Vegas guys just want the hottest babe.

IRULAN: Vegas guys are like guys from New Jersey. They had the plucked eyebrows, the tight shirts, the gold chains, the frosted tips, and the shades—they were ridiculous. I believe men in Vegas like women who are equally ridiculous, so I didn't feel bad if they didn't try to pick me up.

ARISSA: Men in Vegas all have girlfriends, or wives, girlfriends and wives, mistresses—everything. They're unique, all right.

TRISHELLE: They are like a breed. They like girls with big, fake boobies. For the most part I feel like they are all about their money and the club scene. I dated a lot of people there. Like my sister says, you have to kiss a lot of frogs before you find your prince. Well, I kissed a lot of frogs and I have yet to find a prince.

BRYNN:

VEGAS GUYS JUST WANT THE HOTTEST BABE.

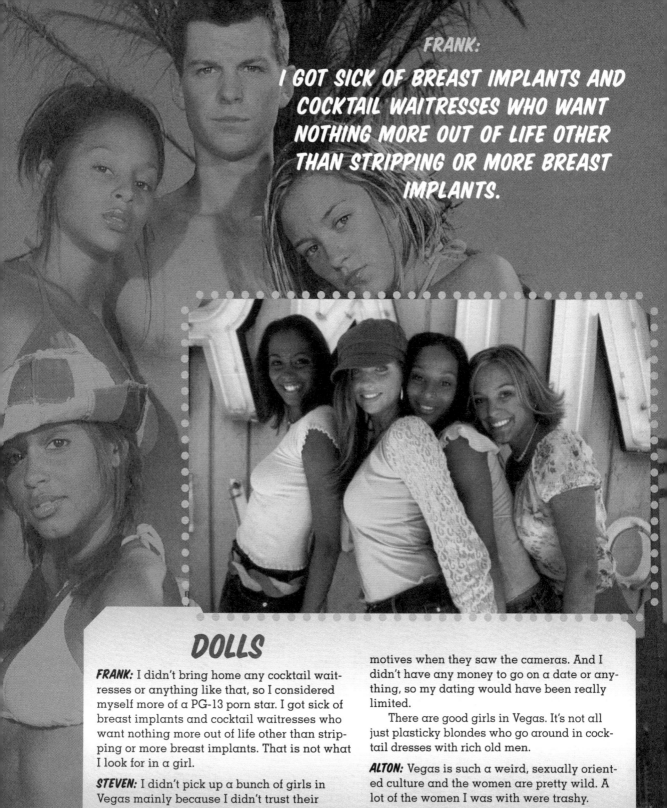

DOLLS

FRANK: I didn't bring home any cocktail waitresses or anything like that, so I considered myself more of a PG-13 porn star. I got sick of breast implants and cocktail waitresses who want nothing more out of life other than stripping or more breast implants. That is not what I look for in a girl.

STEVEN: I didn't pick up a bunch of girls in Vegas mainly because I didn't trust their motives when they saw the cameras. And I didn't have any money to go on a date or anything, so my dating would have been really limited.

There are good girls in Vegas. It's not all just plasticky blondes who go around in cocktail dresses with rich old men.

ALTON: Vegas is such a weird, sexually oriented culture and the women are pretty wild. A lot of the women I was with were trashy.

Leaving Las Vegas

RALIA

IRULAN: Australia was great. We went parasailing, scuba diving, rode camels, went horseback riding, pet kangaroos, held koalas, toured Sydney, chilled on this amazing beach on a resort island. It was just really cool—especially the parasailing. It was such an amazing feeling to be suspended by this one cord, quiet and floating, with the sky above and the sea below.

FRANK: I loved Australia because we did so many things there that I've never done in my life. I think we all left all our petty problems behind. When I was there I started to feel bad about the negative stuff I had been saying about my roommates because they're all good people. Ever since then I did my best to try to be nice to everyone and to say only good things.

ALTON: You see so many stars out in Australia, so many more than you can see in the darkest place in the States. I mean, it was just beautiful. When I think of Australia, I think of Irulan, though.

The guys with the Australia guide

STEVEN: You could just drop your camera anywhere in Australia and you'd have a postcard. It's breathtaking, the weather is amazing, and people were super friendly. For the record, I prefer the wallabies to the kangaroos. They're cuter.

I loved skydiving. It was a really tranquil experience for me. When I landed my heart rate wasn't going any faster than normal.

I was involved in a possum incident there. I had been drinking a lot and there was this cute possum that was nibbling on Frank's finger and it looked really cute. I had two straws in my drink, so I started feeding him liquor. I didn't want to put the straws back in my drink so I put them in my hand and the possum just goes for the straws—and my finger. The possum was dangling from my hand and I screamed like a little girl.

Once we went on a catamaran ride at sunset and we had cheese and crackers and wine. Every time I think of Australia I think of that. That and the possum incident.

BRYNN: I'm not a big fan of flying, so making that long trip was a courageous thing for me. Sydney reminded me a lot of Portland. The people were really nice and friendly and the atmosphere was kind of homey. You're in a different country but it feels familiar.

TRISHELLE: I busted my chin and lost my shoe in Australia! We went walking on the beach and my friend was messing around with me and he took off one of my shoes and threw it on the beach. We couldn't find it then and we thought it had drifted off into the ocean, and I don't know why, but I ran back to the hotel with one heel on. I tripped and fell and busted my chin.

I'll remember that and diving. They brought Brynn and I down together in the water—bad idea, two paranoid people! I was scared that we would freak each other out looking at each other with the goggles on and then drown. But we ended up staying down the longest. I was so proud of us.

ARISSA: For me, Australia was a turning point. It was when I felt I had come full circle and was just more self-aware. I had a lot of time to just be by myself and think about a lot of things that had been going on and a lot of things that I was feeling. When I came back I was somebody totally new.

PERFORMANCE ANXIETY

IRULAN: The performance we put on in Australia was the worst. First of all, Arissa and Trishelle got s**tfaced. We had these ridiculous getups—overalls and flashlights. We were onstage, in a bright club, that had a sparse amount of people and they all looked at us like, "What the hell are you people doing?"

The tape started too low. Nobody was ready, so everybody just ended up free-styling the moves while me and Brynn are in the background on skis still doing the choreographed steps. It was complete chaos. Everybody left Brynn and I onstage and people were laughing at us. It was terrible.

FRANK: I wasn't actually in the performance. It needed to be six performers, I guess, so they claimed that, because I was the engineer, I would be handling the technical side. What really happened was they knew I have no rhythm and I would destroy the performance, but the way things turned out I guess they didn't even need me for that!

The audience was looking at them like, "What the hell is this fourth-grade piece of crap?" What happened? I think a couple of them might have been drunk, and my roommates aren't performers—they were never comfortable with what they were doing.

TRISHELLE: First of all, I was so pissed that Frank didn't have to dance. All he had to do was get flashlight batteries and they didn't even work because the flashlights were so dim. People were looking at us like "Why are you people here and what are you doing?" We forgot the dance and everyone felt like idiots. At the end Arissa and Steven ran as fast as they could off the stage and left the rest of us up there.

ALTON: To tell you the truth, I wasn't disappointed with the performance in Australia. We were out there, we messed up, but I had fun. The crowd seemed to like it—it was funny. I really don't care about making a fool out of myself.

BRYNN: The worst thing about the performance was that Irulan and I had to carry those skis through all of Australia!

STEVEN: Nobody wanted to do it in the first place. It was a humiliating, cheesy, choreographed dance and nobody knew why we were doing it.

ARISSA: After Australia, I thought, if we ever have to put on one of these stupid-ass dance-mania type of performances again I'll lose my mind.

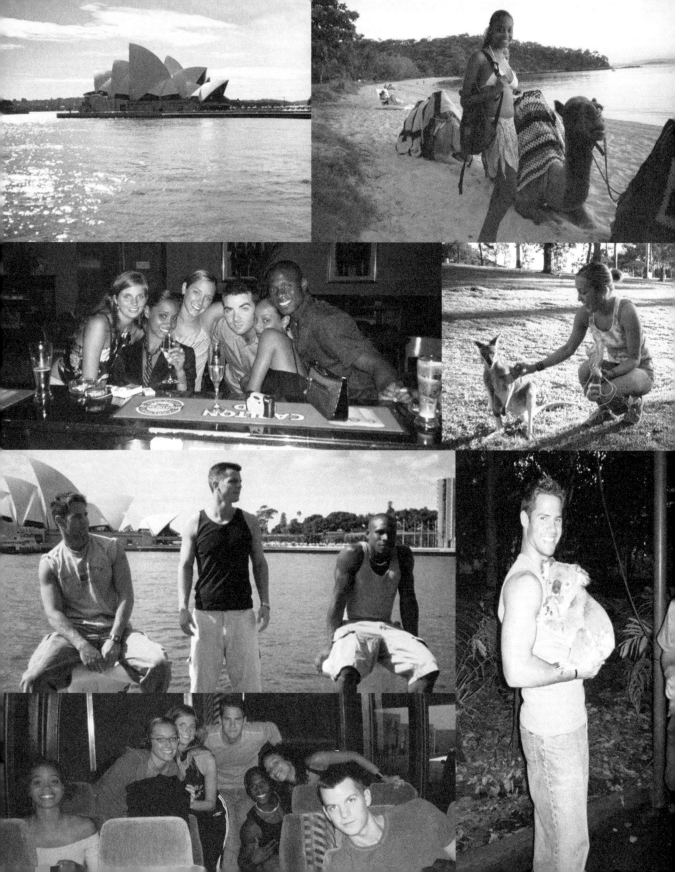

Scenes from

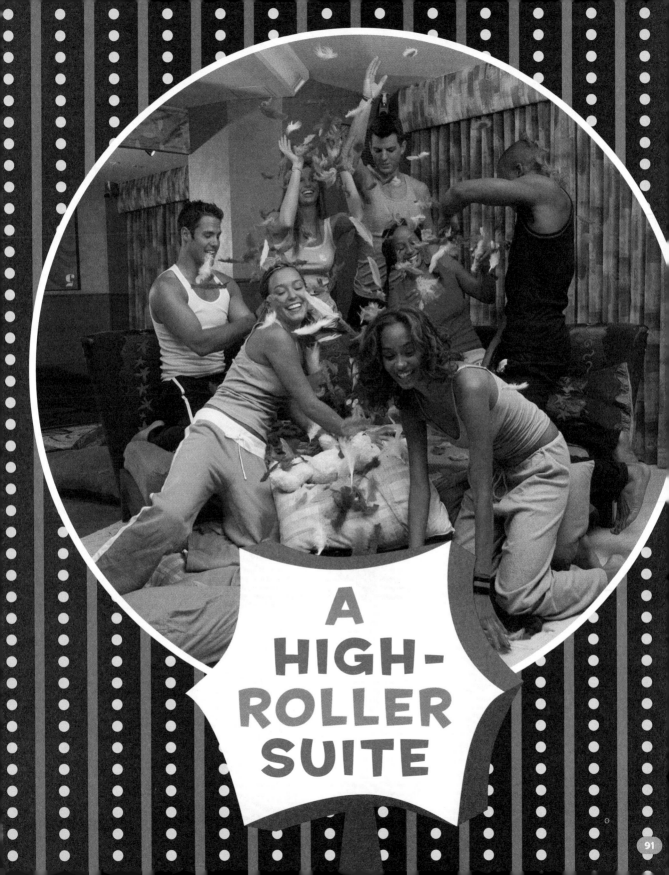

A HIGH-ROLLER SUITE

THE PALMS

JONATHAN MURRAY: We recognized that the plan for the Palms was for it to be the coolest, hippest hotel in Vegas—the place that our audience would find to be the ultimate Vegas fantasy.

DR. LAURA KORKOIAN: The Palms was the perfect size, with the perfect amount of people flowing in and out. They treated us very well and did everything possible to make our job easy. If it was a bigger hotel, it would have been a nightmare. We all would have been more exhausted than we already were, running around trying to find them.

Sometimes when we were off, we would go to the Palms and have dinner or a drink. But the policy was if you're having a cocktail or dinner and the cast shows up, just finish, and then leave. The reason for that is it was their home, their space. After a while we become interesting because we're a mystery and they're tired of their roommates so they start to wonder what we're all about. It's about seven strangers. Not seven strangers and the crew.

Welcome to the Palms
The New Locals' Paradise

PALMS

1 Alizé on 56th floor

2 Ghostbar on 55th floor

CAR WASH

Pool

Pool

Pool

Convenient Parking East
[Off Royal Flush Way]
Park quick and easy in our
two parking garages.

18 Hollywood's salon of the stars. **amp** salon

17 **PALMS SPA**
Luxurious spa and
complete fitness center.

Alizé

1 Gourmet dining at
the top of the Palms.

16 **Blue Agave** Oyster & Chile Bar
Exotic chile and
fresh oyster selections.

2 the ghostbar
Supernatural views
and spirits.

15 **GARDUÑO'S** Cantina
Authentic New Mexican specialties,.
voted 7 times "Best of Las Vegas."

3 **COSMIC CORNER**
Authentic Palm reader.

Logo Shop

4 **RAIN** IN THE DESERT
A sultry 3-story
nightclub.

Front Desk
Check/In

Island Bar

14 **FESTIVAL MARKET** BUFFET
All You Can Eat!
Savory specialties
from around the world.

5 **N9NE** STEAK HOUSE
Chicago's premier steakhouse.

Valet

Keno
Lounge

13 **SUNRISE CAFE**
Great local specials
24 hours a day.

6 **LITTLE BUDDHA**
Asian specialties with
a fresh sushi bar.

Poker Room

2,255 Slots
& Table Games

High-limit
Area

7 **PALAPA** LOUNGE
Cool drinks and hot
live entertainment.

Sports Book
Entrance

Cage

Sports Book

8 **SIDELINES** Sports Bar
Close to the action,
next to the Sports Book.

PALMS
A MALOOF CASINO RESORT

9 **Food Court**
Ben & Jerry's Ice Cream • The Coffee Bean
Garduño's Fresh Express • McDonald's
Panda Express • Pizzeria Regina

10 **Kids Quest**
Fun, safe, supervised
recreation for kids of all ages.

11 **Brenden** THEATRES
All stadium seating and
14 movie screens.

12 **ROLLER** Lounge
Our high-limit table gaming lounge.
Come play and roll your own
cigarettes and cigars.

Convenient Parking West
[Off Arville Road]

TRACY CHAPLIN: At first we didn't know if we wanted the cast to be right in Vegas, on the Strip, or in a nice house a little bit outside the city to experience living out in the desert and being part of a community there. But ultimately, the fantasy is to come to Vegas and live in a casino. But I was concerned: They were in a 24-hour situation and they lived, worked, and played all in the same place.

Being in the Palms, we actually had more privacy being in a public building than on location sometimes, mostly because we had a secured floor so it wasn't like just anyone could come up to the suite. One of the nice things was that Las Vegas is such a transient city, and we were in a hotel where people stay short term. If there were people who didn't care for the production, they were on a plane in the afternoon back to wherever. In general, it made production a lot easier—I didn't hear one "Real World sucks" from my office window at all this year. That was nice.

FRANK: I'm going to miss the convenience of the Palms. If we wanted to work out, or go to the spa, to one of five restaurants, or to a movie it was all downstairs—just a matter of hitting an elevator button. It would be ten times more difficult even if everything was just right next door and we actually had to go outside. That's why we didn't leave the Palms 90% of the time. It was easy living, and on top of that, very good living.

STEVEN: I'm really going to miss the Palms. I had a gym downstairs, a Mexican restaurant, a Chinese restaurant, and a movie theater. That's pretty much my heaven.

ALTON: Living in a casino was a crazy non-stop party. I liked the fact that there was air conditioning, alcohol, nightclubs, food, movies, girls, pools, and a full spa, and that we had access to all of it. But since the Palms had everything I wasn't that motivated to get out.

ARISSA: Living in the Palms was honestly great, because there was always something to do. I could get something to eat, watch a movie, gamble. But I also would have liked to have grass and a backyard with trees—the elements of home.

TRISHELLE: I think that the fact that we lived in a hotel is what made the drinking so excessive—there were all these bars under our roof! In the end I think I would rather have had more of a normal life somewhere away from the Strip. Living in a casino was not normal.

BRYNN: We had a club above us, and a club below us, and we didn't have to drive anywhere. We didn't even have to walk outside. But that might have been a disadvantage because we didn't see a lot of Las Vegas—we were in our own little bubble.

IRULAN: I'm just a regular girl from the Bronx, so it was nice to have a pool outside, where I could just lay out and sun myself and have a cocktail, and a full spa with a salon, and all those different restaurants. I was expecting that we were going to live in a desert ranch or something like that and that would have been a very different experience. Maybe we wouldn't have been going out as much.

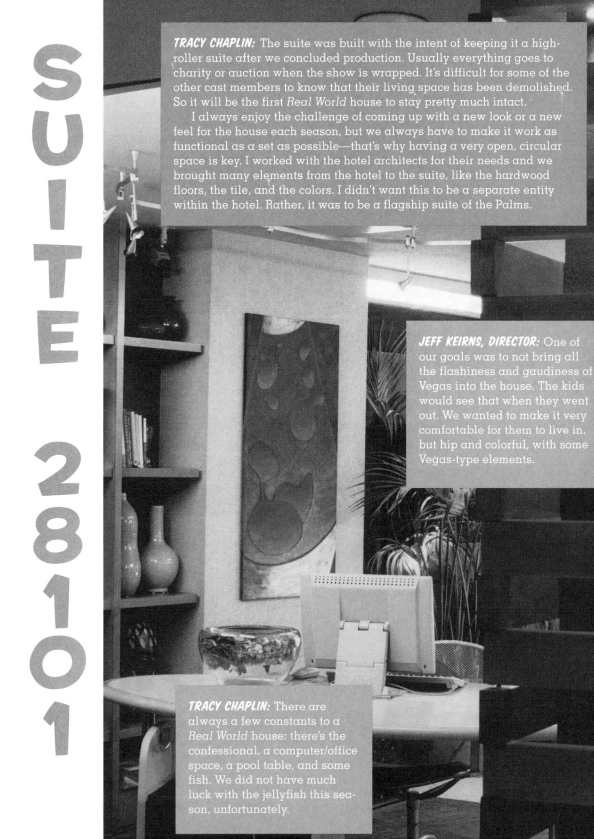

SUITE 28101

TRACY CHAPLIN: The suite was built with the intent of keeping it a high-roller suite after we concluded production. Usually everything goes to charity or auction when the show is wrapped. It's difficult for some of the other cast members to know that their living space has been demolished. So it will be the first *Real World* house to stay pretty much intact.

I always enjoy the challenge of coming up with a new look or a new feel for the house each season, but we always have to make it work as functional as a set as possible—that's why having a very open, circular space is key. I worked with the hotel architects for their needs and we brought many elements from the hotel to the suite, like the hardwood floors, the tile, and the colors. I didn't want this to be a separate entity within the hotel. Rather, it was to be a flagship suite of the Palms.

JEFF KEIRNS, DIRECTOR: One of our goals was to not bring all the flashiness and gaudiness of Vegas into the house. The kids would see that when they went out. We wanted to make it very comfortable for them to live in, but hip and colorful, with some Vegas-type elements.

TRACY CHAPLIN: There are always a few constants to a *Real World* house: there's the confessional, a computer/office space, a pool table, and some fish. We did not have much luck with the jellyfish this season, unfortunately.

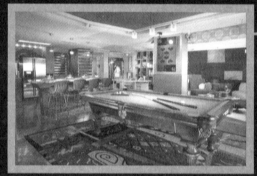
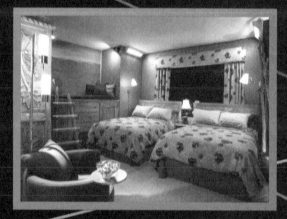

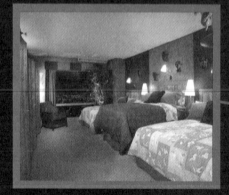
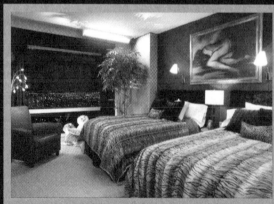

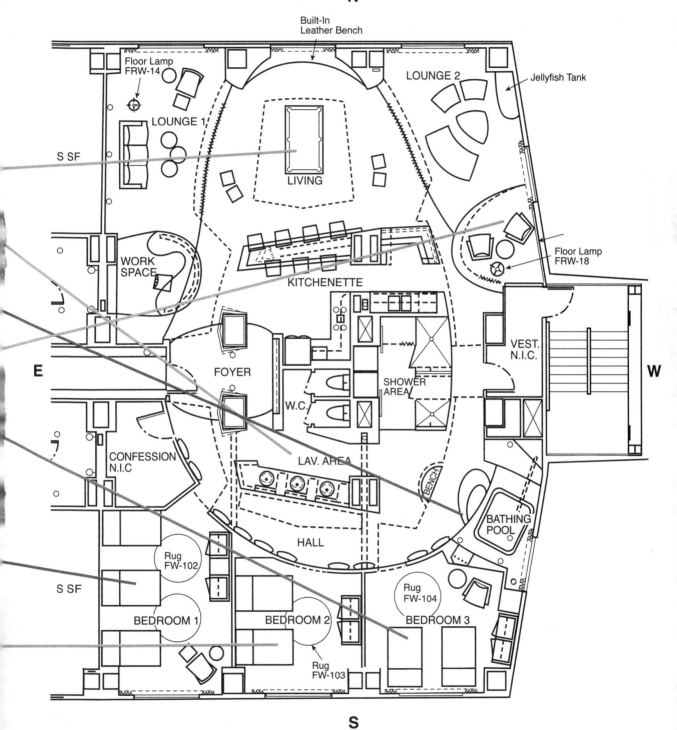

N

Built-In
Leather Bench

LOUNGE 2

Jellyfish Tank

Floor Lamp
FRW-14

LOUNGE 1

S SF

LIVING

WORK
SPACE

KITCHENETTE

Floor Lamp
FRW-18

FOYER

VEST.
N.I.C.

W.C.

SHOWER
AREA

W

E

CONFESSION
N.I.C

LAV. AREA

BENCH

BATHING
POOL

HALL

Rug
FW-102

Rug
FW-104

S SF

BEDROOM 1

BEDROOM 2

BEDROOM 3

Rug
FW-103

S

ALTON: I come from a huge family, so I'm used to living with a lot of people. Still, it was hard not having my own space and my own room.

IRULAN: The suite was comfortable and colorful but it was definitely smaller than I imagined it would be. Seven of us living there were on top of one another, so things got pretty messy. But, it was definitely bigger than my apartment in New York.

ARISSA: I loved the suite. The only thing I did not love about it was there was something there that would move s**t around in my room and I would misplace everything. There's a definite black hole there where I would find pairs of socks, lipsticks, everything.

FRANK:

I DIDN'T LIKE THAT THERE WERE NO DOORS.

BRYNN: Sound carried very well in that space, and when people came home, if you were trying to sleep, that was just not going to happen. There were a lot of sound issues that limited things you could do. Plus, there were no windows that opened—no fresh air. But all in all, it was a great place. I want to come back, if it is still around when I get married, and have my bachelorette party in the suite.

TRISHELLE: The suite was comfortable if a little small for seven people—that's why I'm surprised we got along as well as we did. The one thing I hated, though, was the computer. I wanted to take that computer, bash it with a baseball bat, then take it up to the Ghostbar and throw it over the balcony because it was so freakin' slow.

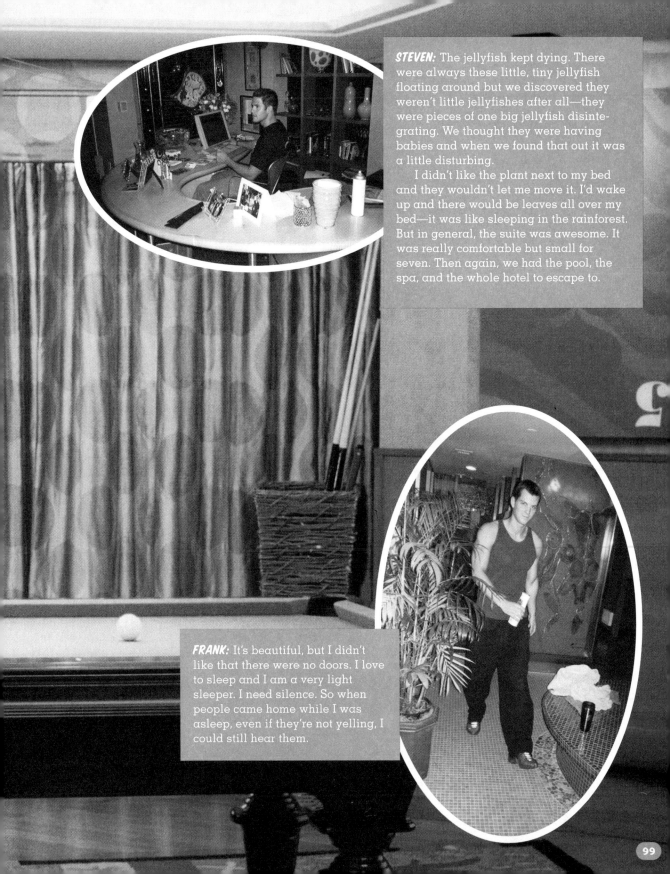

STEVEN: The jellyfish kept dying. There were always these little, tiny jellyfish floating around but we discovered they weren't little jellyfishes after all—they were pieces of one big jellyfish disintegrating. We thought they were having babies and when we found that out it was a little disturbing.

I didn't like the plant next to my bed and they wouldn't let me move it. I'd wake up and there would be leaves all over my bed—it was like sleeping in the rainforest. But in general, the suite was awesome. It was really comfortable but small for seven. Then again, we had the pool, the spa, and the whole hotel to escape to.

FRANK: It's beautiful, but I didn't like that there were no doors. I love to sleep and I am a very light sleeper. I need silence. So when people came home while I was asleep, even if they're not yelling, I could still hear them.

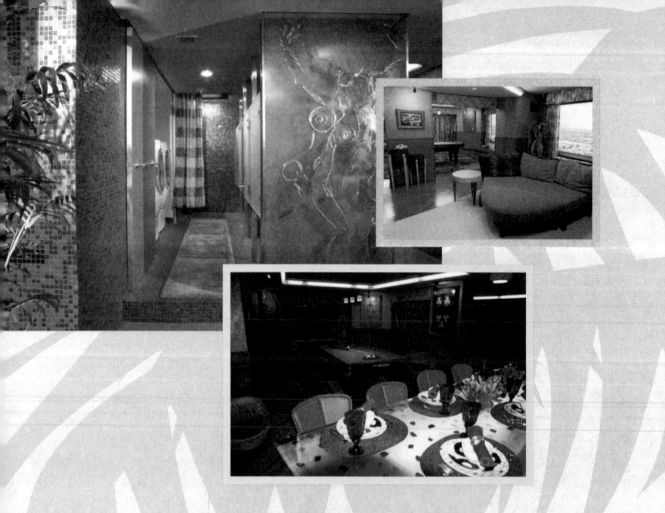

THE SCOOBY VAN

ALTON: Scooby was cool. It got me around. Even though we didn't leave the Palms much, we were mobile and free.

IRULAN: I drove Scooby. At first it was a little bit of an adventure because I drive a much smaller car but I got the hang of it.

TRISHELLE: When I first saw that thing I was like, "I can't drive this!" Then one day I took it out by myself and it was the windiest day ever and it's so narrow and tall it was swaying back and forth.

We have a pop-up bed on top of it and it took us four months to find it. We could have been sleeping in there at night!

BRYNN: I thought Scooby was cramped and messy. It was full of garbage and greasy handprints.

STEVEN: Try picking up women in the Scooby van! It's not happening. Actually, Frank and I did once. We were driving down the Strip one day and there were two or three girls who thought it was really cool.

ROAD RULES INVADES

MARY-ELLIS BUNIM: We challenged the *Road Rules 11* cast to get into the *Real World* suite completely undetected—and they pulled it off!

ARISSA: *Road Rules* played us out and got into the suite. They sent the really, really beautiful ones to put down our defenses. I don't know how Irulan and I could invite in some sketchball that we had never met before, but we did. Then Steven let two of the women in and again, they were beautiful, and his defenses were completely down.

TRISHELLE: The girls found Steven and they handcuffed him to the jacuzzi. He picked his way out with a bobby pin. Good thing Brynn and I always left our bobby pins in there!

We had a competition and we represented. We all came together as a group that weekend and we kicked their butts. We had a tug of war and I don't care what they say, we won. I was thinking they would be so much more competitive than us. I mean, we were drinking and going to the spa every day while they were supposed to be competing all the time. We creamed them at everything.

IRULAN: When Arissa and I spotted Darrell in the casino, we were like, "hello!" He's very handsome and we started talking to him and we didn't know he was a Road Ruler, so we invited him up to the suite. Right before that one of the security guys tipped us off that there were these young people asking questions about us in the hotel. Once we had Darrell in the elevator, we started to get suspicious so we ran into the suite and didn't let him in.

Ultimately, Steven was always the one to crack. He got handcuffed to the hot tub by Kendal, Rachel, and Raquel and they stole our phone. We ended up getting revenge by sneaking into their RV and stealing stuff and then we beat them in the competition.

BRYNN: Steven came down to me when I was working and he kept saying, "I'm so stupid! I'm so stupid!" but I didn't really find out what happened until I got off of work. The challenge was a really good time, especially because it was great to meet another group of kids who were going through the same thing that we were.

ALTON: Lake Mead was beautiful and I knew we would win. I was so proud of how resolved all my roommates were to win even after all the complaining. I was most surprised by Irulan and Brynn's competitive nature—I loved that.

STEVEN: I'm really not a big competitor, so when Raquel and Rachel came in, I was like, "I don't care," so I showed them the apartment. But I did think that they were going to let me out of the handcuffs, and that they did not do. I, however, got out of the handcuffs really fast—in about 7 or 8 minutes. It's amazing what you can do when you have to. I was very proud of myself.

FRANK: I thought the *Road Rules* weekend was one of the most fun weekends I've ever had. First of all, I thought the Road Rulers were all great people. I looked at Eric and thought, "he's me!" I liked meeting all of those guys. Then we did all these crazy competitions, like we had a "break the seal" competition where we drank water until we had to go to the bathroom. We also did a wrestle off, which was the stupidest thing I've ever done in my life.

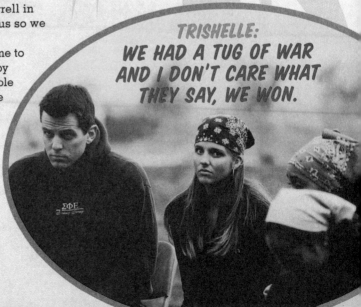

TRISHELLE:
WE HAD A TUG OF WAR AND I DON'T CARE WHAT THEY SAY, WE WON.

Sin City

CONFESSIONALS

Brynn's CONFESSIONAL

Arissa and I got into it today about work. I really don't care about work. I just find it a waste of time and I have another job and I'd rather just dance instead of trying to put together this big party. But if it's going to make everybody else happy I'll do it.

· · · · ·

I've been having really bad anxiety attacks, and it's not fun. And it's making me really tired and grumpy all the time, and I don't like it.

· · · · ·

I've thought about going home early because I'm really sick of this whole process. I mean, I'm grateful, and I feel good about the fact that I got the opportunity to do it, but it's just overwhelming me and I don't know if it's going to get any better. I guess it is what I make of it, but this whole partying every night is really getting to me.

· · · · ·

I really, truly love all my roommates and I am going to miss them a lot. I might not show that and I might not say it enough, but I really will. Irulan and Alton: more power to you—enjoy your time together. Trishelle and Steven: Trishelle, Steven likes you. Steven, Trishelle likes you. Make out, have sex, be together. Arissa: don't be with Dario. Frank: be single and mingle with your friends.

FRANK'S
CONFESSIONAL

Trishelle comes up to me all the time and does this baby face and she's like, "Frank, will you hug me?" And I give her a little hug but it's just so hard to accept this little innocent act she puts on while Steven's telling me all the dirty, disgusting details about the two of them having sex every night. But she is a nice girl. Just because she's like that in bed doesn't mean she's not nice.

· · · · ·

Steven is very ugly and it's good that he's compensated for it with his brain. I hope I don't take too many girls away from him while we're here. I sense a little jealousy every now and then. Anyway, I'm having a good time with him and I get along with him the best. He had such a different upbringing from me. I can't believe he's the gentleman he is based on the way he was raised because it sounds to me like he was raised like shit. And he's a polite guy and treats girls great. He doesn't treat girls like shit at all. And I probably don't treat girls that well.

· · · · ·

There are all these trashy girls out here. And I'm hooking up with girls that are drunk and it just makes me feel trashy when I do that. But at the same time what am I going to do, be lonely while I'm out here? But I'm not going to do anything serious with any of these girls.

· · · · ·

When I was here for the first week or two, I was doing confessionals all the time. I just had all these thoughts in my head, so I came in here and I talked and I talked and I talked. Then, my roommates were just so damn loud that I started sleeping in here. It's padded, it's sound proof, so why not? And plus it has a door, a beautiful door with a doorknob. Maybe I kissed a girl or three in here, too. And I may have hooked up with a Hooters waitress in this chair.

Arissa's
CONFESSIONAL

Let's start off with me breaking up with my boyfriend. Do I feel bad about it? Yes I do. But I feel like I'm having a blast right now. And I've never been single. I've never taken the time to be single and learn about me, what I do, and how I do it. Now that I'm having so much fun with no worries, it makes me regret not doing what I'm doing now when I first walked in. I'm glowing. Everything is great.

· · · · ·

I confess that at least maybe three out of four roommates had sex in this confessional.

· · · · ·

I confess that Alton probably has the biggest woo that I have ever seen in real life.

· · · · ·

I really hate doing confessionals. I hate this. I hate doing them by myself, because I feel like I'm talking to myself. You're probably going to have to physically force me to do one every day. And then maybe I'll be better at it, at the end of the month. Maybe later on I will drag Irulan in here or somebody to confess with me. Okay? But I can't do it now. That's all I have to say about that. Now I'm done.

Trishelle's
CONFESSIONAL

I'm never outspoken and the fact that Irulan thinks that I have an attitude is just beyond me because from day one she's had an attitude. I was the nice girl when we first got here, who never really said much and kind of kept out of conflicts. But I feel like living with the people who I live with, it is hard to avoid conflict because they are mouthy and I've never had to deal with that before and I'm not going to deal with it now, so that's it.

• • • • •

I probably need to apologize to Brynn because in the beginning she might've liked Steven. And I hooked up with him anyway. But that was unintentional. She didn't really come out and say that she liked Steven. And plus she liked a ton of other boys and she was hooking up with other boys, too. But still I guess that was kind of crappy of me.

• • • • •

I confess to forgetting about the surveillance cameras.

• • • • •

I'm going to miss everybody so much. And I know that there have been times when I felt as though I wanted to go home, or just frustrated with people, or upset or angry, or salty. But Steven, Frank, Irulan, Arissa, Brynn, Alton— I love you guys so much. Thank you, thank you, thank you, for helping me grow and for helping me see myself a little bit clearer. Thank you for all the memories, all the laughter, and the late nights. I hope we meet again, because I'm not ready to say goodbye.

ALTON'S
CONFESSIONAL

There is one secret I need to tell. When I was driving to the climbing gym one time, some lady in this red Durango hit me from behind in the Scooby van. I pulled over and I got her information and I went back and I looked and her car was fine, the Scooby van was fine, so I didn't make a big deal out of it. But I definitely did get hit from behind in the Scooby van.

• • • • •

My favorite moment in the confessional was the confessional I had after my first time having sex with Irulan.

• • • • •

My woo isn't as big as they think. It's nine and three-quarters, regular. It's not the eighth roommate—it's not that crazy.

• • • • •

At the end of the day, I love Steven, I love Frank, I love Trishelle, I love Brynn, I love Arissa, and I'm in love with Irulan with all my heart. They're just great people. And I know I'm going to keep them in my life. And it sucks that we all weren't friends the whole time, but when are you always friends even with your best friends? Everyone has a breaking point, everyone has that point where they can't handle it, or they stick their big foot in their little mouth.

Steven's
CONFESSIONAL

I think Frank's going to be one of my best friends for many years. And the fact that I'm walking out of this with one, possibly two, really great friends—you can't beat that because good friends are priceless. It's funny that Frank's and my relationship started off the way it did—me doing that crap with Trishelle right in front of him. And Frank looked past that and gave me another chance. I'm so thankful for that, because without Frank being here, I wouldn't have been anywhere near as happy. He's kept me grounded, he's called me out when I'm wrong, and he's backed me up when I'm right. You can't ask for more from a friend.

• • • • •

I treated the confessional as a motel room sometimes. And that's just not the thing to do. I didn't pay my twenty dollars an hour, so, it's bad.

• • • • •

I actually don't want to know how my other roommates misused the confessional. I know there was some nookie going on in here. And violin playing. Both make me equally as uncomfortable.

• • • • •

Alton's woo would scare most racehorses. It's gigantic. I'm forever scarred by waking up one morning with his woo hanging over the side. It damn near touched the floor.

IRULAN'S
CONFESSIONAL

I think it's really good that Brynn and Trishelle have been able to have a conversation and meet some sort of understanding that, under different circumstances, they wouldn't necessarily be friends, but they're going to be civil, and they're going to deal with each other with respect. I think that that's really important. Because Brynn can come out in a way that maybe people take as aggression or hostility, and Trishelle is at a point where she's not going to deal with it anymore. I think that it would be pretty uncomfortable for all of us if that were going to continue for the remainder of our time here.

• • • • •

I definitely hope that Alton's somebody that can be in my life as a friend always. But in terms of the romance and the relationship, it's crazy. I don't know what's going to happen once this is all over and how we're going to feel when we get home. And I think that it causes me to respond in certain situations a lot more emotionally, because I'm just sort of unsure. And at this point my heart is in it. I really, really care about him. And I don't know what we're going to do. And it's scary.

• • • • •

I don't think it's a secret, but Frank farts. We call him Frank Farter.

• • • • •

Alton's woo is a ten foot pole. I don't have anything else to confess. That's my story and I'm stickin' to it.

SIN CITY
Behind the Scenes

THE CAST
ON THE CREW

FRANK: Here's the deal with the cameras: at first you keep in mind, everyone's watching me every second of the day. But then it's natural for you to forget and start acting like who you really are. A big reason for that is that we're not allowed to know the crew members' names, we're not allowed to talk to them, and so we're not inhibited by their personalities. They're like ghosts to us because we really don't know them and they do a really good job of making us feel comfortable in front of the camera.

That said, after a few months you get sick of them. You want to embarrass yourself and make bad decisions and not have everyone judging you. Because that's what everyone is really afraid of—being judged.

STEVEN: Sometimes the cameras were really creepy because they were quiet and sneaking up behind you all the time. I would wake up in the morning and there would be three guys over me—that was a little weird. I proceeded to trash the area around my bed so they wouldn't sneak up on me while I was sleeping.

We had some very, very cute crew members. There was this one girl who joined the crew in the end who was just the cutest little thing in the world—she was so distracting. I'm so glad she wasn't there the whole time.

ARISSA: In the very beginning I would change clothes in the closet and when I brushed my teeth I would hold up a towel. Soon, I started not to care.

If anything the presence of the cameras made me a lot more honest than I could probably be ever in my life. You have no choice but to be honest. It has to be real.

I wanted "Jerome"—I think his real name is Brett—and I couldn't stop talking about it. I would make so many jokes about Jerome being under my bed. I think everybody knew about my crush on him.

FRANK:
We're not allowed to know the crew members' names, we're not allowed to talk to them, and so we're not inhibited by their personalities.

Josh Mayes

Brett Alphin

Doug Henning

ARISSA:
I wanted "Jerome"—I think his real name is Brett—and I couldn't stop talking about it.

Rollen Torres (on camera) with Lee Cote

Mike Kalili

BRYNN:

There were some days that I would have a really bad day with the cameras, and there were other days when I would wake up and not even know they were there.

BRYNN: It was hard at first but I think I adjusted surprisingly fast to the cameras. And I readjusted surprisingly fast when they went away, too. It's really hard to have a camera in your face all of the time. There were some days that I would have a really bad day with the cameras, and there were other days when I would wake up and not even know they were there. It was dependent on my mood and the day and who the cameraperson was.

I did have a few crew crushes but I think they felt like I was their little sister or something. Sometimes I would put on some perfume if I knew a certain someone was miking. And there were a lot of fun little flirty comments we would make to them.

TRISHELLE: I got used to the cameras on the second day and then they just faded into the background. I wish I could say I changed my behavior when I was aware of the cameras, because I did some embarrassing things.

I'm not going to miss being miked up every day because I had the worst clothes for the mikes. The crew had to deal with things like that and I respected the crew more at the end. Their job is so hard, and I'm sure dealing with us wasn't easy. And so many of them were cute. I had a lot of crew crushes.

IRULAN: I'm not going to miss the lack of privacy. A person needs downtime and you need to reflect and feel and think on your own sometimes. But that wasn't the crew's fault. They were just doing their jobs.

I had a huge crush on the guy whose nickname was Dean Martin. His real name is Michael Pepin.

ALTON: I never got used to the cameras. I know I put myself in this situation, but they're very close to you sometimes when you're just trying to act normal. I got irritated with them sometimes—I just couldn't help it.

The crew all seem like good people, though. But unlike everyone else, I didn't have any crew crushes. Just Irulan.

ALTON:

I GOT IRRITATED WITH THEM SOMETIMES— I JUST COULDN'T HELP IT.

CREW CHALLENGES

TRACY CHAPLIN, PRODUCER: The casino culture made shooting in Las Vegas a challenge in terms of where we could and couldn't go. Some of the bigger, more enticing properties wouldn't allow us to shoot there. A lot of the smaller properties were gracious and let our cast come to them. But luckily, the kids didn't leave the Palms much, anyway.

MICHAEL APPLEBAUM, DIRECTOR: When I first started in Vegas I said, "Are we going to be able to shoot anywhere? Can we go into casinos with cameras?" And I was actually surprised that about 50% of the big casinos did allow it.

BRETT ALPHIN, AUDIO ENGINEER: Vegas is a beautiful city on camera, but in terms of audio, it is not a very good environment for clean sound. There are nightclubs with music at 30,000 decibels, and casinos are really loud.

JEFF KEIRNS, DIRECTOR: One of the biggest challenges was that everyone, except for Brynn, didn't know where the heck they were going around town. Alton was the worst. He never used a map and would always get behind the wheel and just try to figure it out. My entire crew was extremely frustrated because we always knew the right way but there was nothing we could do.

ROLLEN TORRES, CAMERA OPERATOR: Las Vegas does not sleep, so we were always trying to catch up with the cast. They were up pretty much 24/7 and there were always at least five of them up and about.

ROLLEN TORRES:

LAS VEGAS DOES NOT SLEEP, SO WE WERE ALWAYS TRYING TO CATCH UP WITH THE CAST.

CREW COMPASSION

JEFF KEIRNS: The whole cast had gone through some hard times in Vegas and watching them grow and get through them has been wonderful. I think it's even harder for a director to keep emotional distance because we have a line, but we do talk to them and you need them to listen to you and to respect you but you can't be their best friend either. This cast in particular was good at not asking the directors for their opinions, so that was good.

REGINALD LA FRANCE, DIRECTOR: I struggled between wanting to strangle the kids sometimes and wanting to put my arms around them and give a hug and say, "Aw, it's not that bad."

BRETT ALPHIN: It's hard when the cast is going through emotionally bad times, but it's just as hard for us to try not to laugh or smile when they're happy or doing funny things.

We share a lot with the kids—we are right there experiencing every emotion with them. That hug at the end from the cast—the "thank you for being a part of this experience with me" is so rewarding. I can't think of any other show business job where I'd be doing sound and someone would hug me and thank me.

CHRIS POWELL, SUPERVISING AUDIO MIXER: It's bizarre because we've been a part of these peoples' lives in a hands-off way for a long time, but by the end they feel that they know a little something about us—they give us nicknames and everything. What's weirder is when we wrap and we are finally allowed to talk to the cast I approach it like I'm meeting them for the first time, even though I know so much about them.

Jeff Keirns, director

LEAH COLE, CAMERA ASSISTANT: It was hard to separate myself from the kids because I like to be a part of people's lives and ask questions. I'm happy when other people are happy and it's hard for me to see when other people aren't happy. I wanted to show them that I cared but I couldn't.

ANDRES PORRAS, DIRECTOR OF PHOTOGRAPHY: Every time they laughed, cried, or got angry they grew more and I was there to see that and acknowledge that and that changed me. I grew with them and I learned that I related to them in a lot of different aspects. The hardest part was not being able to comfort them during the tough times.

CHRIS POWELL:

What's weirder is when we wrap and we are finally allowed to talk to the cast I approach it like I'm meeting them for the first time, even though I know so much about them.

TELL IT LIKE IT IS...
INTERVIEWS

Steven with Dr. Laura Korkoian

DR. LAURA KORKOIAN: Interviews were always on Monday, from about eight or nine in the morning until about seven at night, with a break for lunch. Two directors would conduct the interviews in two different rooms simultaneously.

I couldn't force the kids to talk, but I would want to understand why they wouldn't talk about a certain thing. So I would ask them, "Why don't you want to talk about it? Or what is it that you don't want to share?" Sometimes they didn't really want to talk about something because they didn't want to relive it again. But the reality is that we have it on tape and there's a strong possibility that it will be shown. So I tell them that this is their opportunity to have their voice. Their failure to speak will actually make it worse. The moment they start to close down, they do a disservice to themselves. All sides of the story won't be told.

FRANK: I loved the interviews because they were so therapeutic. I like talking, and it's two or three hours every Monday where you go in and discuss your life and everything you're thinking about. Sometimes it kind of sucked because you're tired and there were all these bright lights, you sit in an uncomfortable chair, you're sweaty, and you look like crap on camera, but the actual process was so satisfying.

Dr. Laura especially was so insightful. She explains things to you and you're like, "That IS true! I didn't know I was upset about that but you're right!"

ALTON: The weekly interviews were cool. I liked being able to go in there and say whatever it was that I was feeling at the time. Sometimes they asked questions you'd rather not answer, but the interviews were a very special part of the overall experience.

IRULAN: In the beginning of the interviewing process, I tried to maintain my walls and boundaries but Dr. Laura definitely saw past that. It's difficult because you're supposed to talk in the present tense about things that happened a week or two ago. But at the same time, the interviews were healthy to reflect on what was going on. During the whole Alton, Australia, "I'm going home" fiasco, Dr. Laura sat on the floor with me and rubbed my back while I was bawling.

ARISSA: Those were hard Mondays. I would go in there knowing I had to face up to some stupid thing that I did or said or some drama that had gone on the week before, and I dreaded it, but it forced me to look at my actions constantly.

DR. LAURA KORKOIAN: Arissa walked out of interviews a few times. We were talking about some very painful emotions and it's scary to be vulnerable in that room. We had no relationship because we never talked outside of the interview situation. And there I was asking some very personal questions.

TRISHELLE: Whatever mood you were in that day reflected on how you answered the questions. So if Brynn pissed me off five minutes before I got to the interview, I would be talking about her the whole time. I got to blow off a lot of steam, and Dr. Korkoian put things in perspective for me more than anyone. She would totally nail it.

The hardest part was when I had to talk about my mother, but the thing that bothered me the most was when everybody always wanted to talk about me and Steven. I didn't care to talk about it and I didn't think there was much to talk about. That was always the point in the interview when I didn't want to be there.

DR. LAURA KORKOIAN: I would say to Trishelle, "Let's think about why it is that I'm asking you about Steven every week? Why is it that I have nothing else to ask you about?" It's just so we have a richer sense of what's going on.

STEVEN: I looked forward to the interviews. I lost it a couple of times, though, and it was a difficult process.

BRYNN: I especially dreaded going to interviews when they were before noon. Some of them were really tough to get through because they were emotionally challenging, but I would walk out of the interviews feeling really good about things. I miss them actually. I still wish I could have them every week.

DR. LAURA KORKOIAN:
Arissa walked out of interviews a few times.

IRULAN:
DURING THE WHOLE ALTON, AUSTRALIA, "I'M GOING HOME" FIASCO, DR. LAURA SAT ON THE FLOOR WITH ME AND RUBBED MY BACK WHILE I WAS BAWLING.

ESCAPE!

IRULAN: I did break away one time and I got into a lot of trouble for it. We were at a Pink concert and it was very crowded and we went downstairs to stand in a pit of people. The cameras were nowhere in sight, my friend and I looked at each other and said, "Let's go!" We got in the car and started driving and the next thing you know my pager's going off. They were not happy.

FRANK: If you were by yourself you could get away everyday for almost an hour or so. About halfway through I had to go to L.A. because I applied to USC and I needed to go for an interview there. Steven and Trishelle wanted to go, too, so we all went. There was only one crew out there with us and they couldn't be with us all day and all night so they left us alone for hours. It was then when I realized how much I missed my freedom and private life. Right after California, the shackles went right back on and we were underneath the microscope again.

BRETT ALPHIN: The hardest part of my job is making the cast get miked and making sure they are wearing their mikes. Sometimes they would try to cover their mikes up, but it wouldn't work. If they were whispering or covering up their mikes, obviously they were saying something we might want to hear, so I would just throw up the boom.

BRYNN: I would say that I was going to a friend's to swim, and if you're swimming they have to take the mikes off. Also, the cameras weren't allowed in Wal-Mart, so I was able to go shopping like a normal person. I felt lucky the few times I had those opportunities because it kept me sane in a sense.

ARISSA: What I would do is make my roommates have a good conversation. I would say, "Why don't you talk about that issue you were talking about yesterday," and then when the attention wasn't on me, I'd take off.

NOT CAMERA SHY

TRISHELLE: I was skeptical of a lot of people because many people we met had ulterior motives. The best thing was the people who didn't like the cameras because they were the ones who wanted to hang out with me, not Trishelle *Real World*. I'm not going to miss wondering if people had an agenda. That's usually not like me, and I can get really paranoid.

IRULAN: Something that was hard to deal with was that there was a fair share of people who wanted to be friends with us because of the cameras. But in all fairness there were also people who didn't give two s**ts about the cameras and who genuinely liked us for who we were.

STEVEN: Some people definitely became friends with us just to be on camera and that's why I didn't trust a lot of girls. Then the downside is that I met one woman who said we couldn't see each other because she didn't want to be on camera at all.

ALTON: Girls would do crazy things like come up to the suite and get naked just to be on camera. Sometimes random guys would come over if we were sitting down and having a conversation and sit right in the middle of us and start smiling at the camera. It was so weird!

FRANK: I'm just some dumb kid from Pennsylvania, so I've never had to deal with people with ulterior motives before. In Vegas I was always wondering if a woman was with me because the cameras were around. I wodered— are they trying to be on TV? Or do they really like me? You're always questioning it and that's a really bad thing.

BRYNN: In Vegas a lot of people are trying to push their businesses. So there were a lot of people giving us free stuff or handing us their business cards or schmoozing us and I found it funny because we have no control over what ends up on camera.

Then there were people who I was getting to know who I thought were truly genuine, and then I would hear from others that they were using me to get on camera. That sucked.

ARISSA: I felt like I could always tell when people weren't genuine. There was this one gentleman who we thought was cool in the beginning. But then he started talking about his singing career—a lot. And then he started singing to us—every time he saw us. Then one time we were at Ghostbar and the next thing you know his CD comes on. And any time we were around him he would get his CD on somehow. That was damn tiresome.

BRYNN:

So there were a lot of people giving us free stuff or handing us their business cards or schmoozing us and I found it funny because we have no control over what ends up on camera.

Casting

LAS VEGAS

MARY-ELLIS BUNIM: Over the last twelve years, we have gotten close to 300,000 applications in total and currently we're getting 35,000–40,000 a year. We start the casting process by looking for people who are quite different from anyone we cast before, so no one is drawing an immediate comparison to last year. We try to start all over and think in terms of the new environment, and in the end we get good stories because of the attention we pay to casting. If the people aren't interesting, you don't have anything to watch.

JONATHAN MURRAY: In terms of casting Vegas, I suppose we wouldn't want to knowingly put an alcoholic there—but we wouldn't want to knowingly put an alcoholic in any of our shows. That doesn't mean they don't make it in. We also wouldn't put someone we knew was an addictive gambler in Vegas either—that would have been setting up someone to fail. Otherwise, it's the same criteria we've always used: they have to be unique, they have to have a sense of humor, they have to have an interesting perspective, and they have to be open enough to learn from the experience.

MARY-ELLIS BUNIM: They must be articulate and willing to open up their lives. For Vegas, we looked for people who haven't had this experience—for example, Frank and Trishelle are from very small towns and were wide-eyed when they arrived. We also required them to be at least 21 because they had to be employees of the hotel. We thought that was an easy adjustment to make.

DR. LAURA KORKOIAN: During casting, I look for good coping skills. We need to make sure that nobody hurts themselves or another cast member, so we look for an ability to check themselves. I like them to have some sense that the world isn't falling apart underneath them. I want to learn: What are their support systems? What do they do when they're upset? How much of their history has been real serious stuff, like drug use or depression? Were they suicidal before? And then we have to question: Would this environment be best for them?

We do a lot of background checks. They give us a list of four or five references and we take it from there and make more. When we're in the semifinal stage of casting, we sometimes bring in boyfriends or girlfriends and get their perspectives on what they think about being away from their partners and we get to learn a little bit more by speaking to them in person.

There are four intensive interviews. In the casting department, we study them. Our job is to make sure that coming in this door we know who this person is, or at least the qualities they possess, the struggles that they're facing, and the cards that they've been dealt. We have to be very thorough. Once in a while, there's a surprise. But I think we really know 90% of them coming in here. These kids say we know them better than their best friends. I'm very proud of it and I think we do an amazing job.

From the beginning, the Las Vegas cast lived their lives. I think people have been camera shy about getting in a relationship with a roommate in the house in the past. But this cast was just like, "I like this person, I'm having fun with this person, and I'm just going to do it!" There are some things I'm sure they wish they'd never have to relive again, but they always owned up to it—they were like, "I did it. I said it. Let's deal with it." I respect these guys so much for that.

TRACY CHAPLIN: There's an energy to this cast. They were the seven that really made me want to get to know them more. We weeded out all these amazing people, but then there were these bright, shining stars remaining—like a pile full of stones and a few little gold specks. They were just dynamic—lighting up the room, and the screen.

JONATHAN MURRAY: With seven people, if one person turns out to be a mistake, we're protected because there are six other people in terms of story. I think what happened with Las Vegas is that we got seven home runs—and ended up with twenty-eight episodes' worth of story. As a result, it's been a very interesting, enjoyable journey.

APPLICATION BITS AND PIECES

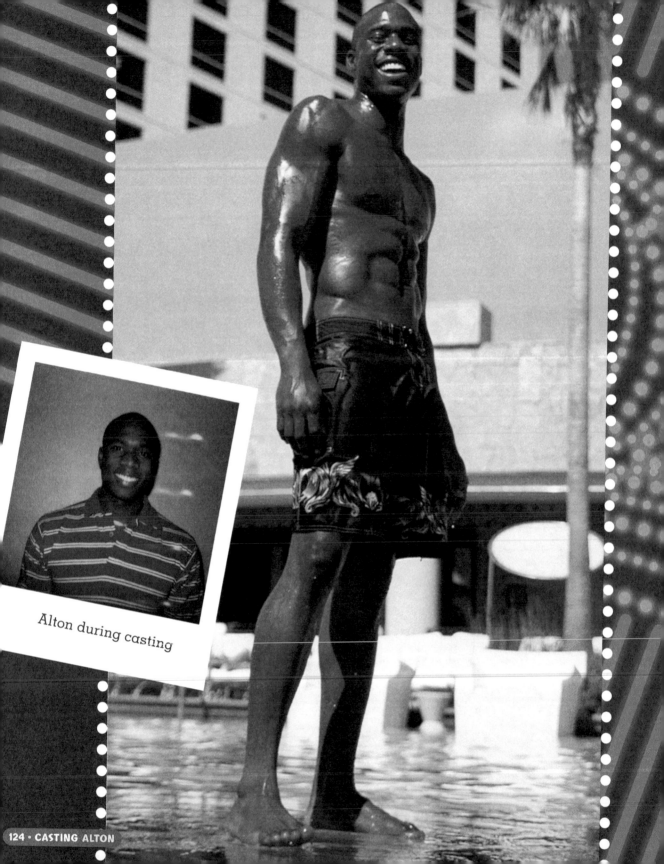

Alton during casting

CASTING

Alton

NAME: Alton

AGE: 22

BIRTHDAY: September 18

PRESENTLY LIVING IN: Spring Valley, CA

PARENTS: Melina and Alton

SIBLINGS (NAMES AND AGES): Natash 20, Jennifer 18, Dennis 12, Tammi 10, Olivia 9, Rebecca 7, Nicholas 6

WHAT IS YOUR ETHNIC BACKGROUND? African, Egyptian, Indian, Blackfoot Native American

NAME OF HIGH SCHOOL: Mount Miguel

NAME OF COLLEGE: Santa Monica College, Pierce College

WHERE DO YOU WORK? DESCRIBE YOUR JOB HISTORY: I've been a veterinary technician for 5 years. This has always been a passion for me.

WHAT ARTISTIC TALENTS DO YOU HAVE? HOW SKILLED ARE YOU? I play violin classically. I perform spoken word poetry. Free-style underground hip-hop. Write short stories. Compose solo pieces for violin. I enjoy dancing—B-Boying-skanking-a little swing. Interior design.

WHAT ABOUT YOU WILL MAKE AN INTERESTING ROOMMATE? I love to laugh even at myself. I'm easygoing yet spontaneous and unpredictable. I love meeting new people with different ideologies and views toward life. I even enjoy a good debate every now and then. But I think the main ingredients to being a roommate are room, respect, reservation, and resolve. I have that in the mix of my personality, so I feel confident that I'd be at least interesting as a roommate.

HOW WOULD SOMEONE WHO REALLY KNOWS YOU DESCRIBE YOUR BEST TRAITS? I think they would say that I'm loyal and honest. I'm always trying to help others see their greatest potential. I'll do anything within reason to help a complete stranger. I think anyone that knows me knows that I am a firm believer in Karma so I treat people in the present how I would like to be treated in the future.

HOW WOULD SOMEONE WHO REALLY KNOWS YOU DESCRIBE YOUR WORST TRAITS? I tend to try and juggle more than any one person can handle. I'm really hard on myself and expect only the best from myself. Maybe a little too nice at times. I've been told that my kindness can easily be mistaken for a weakness and often is, it seems.

DESCRIBE YOUR MOST EMBARRASSING MOMENT IN LIFE: In junior high, before I learned the art of self-control, in math class my mind started to wander and it found ladies. I had a full-on wood and the teacher picks on me for day-dreaming and has me stand up and come to the front of the class. Everyone saw my stiffie and I had to live that down for the rest of that year.

DO YOU HAVE A BOYFRIEND OR GIRLFRIEND? HOW LONG HAVE YOU TWO BEEN TOGETHER? WHERE DO YOU SEE THE RELATIONSHIP GOING? No girlfriend. I've been single for three months and I'm loving it. I see myself staying single for quite a while to build a stronger relationship with myself and my future.

WHAT QUALITIES DO YOU SEEK IN A MATE? I'm looking for a girl that is not afraid to express herself.

Someone brave enough to be real even at the price of being vulnerable.

HOW IMPORTANT IS SEX TO YOU? DO YOU HAVE IT ONLY WHEN YOU ARE IN A RELATIONSHIP, OR DO YOU SEEK IT OUT AT OTHER TIMES? Sex is important to me although I'm not always seeking sex. The last occasion was actually propaganda for celibacy. I met this girl at one of our reggae shows. We went afterwards to watch a meteorite shower, then to her house. While things were very hot—I mean while we were sexing each other up—her ex-boyfriend, who still had keys to her apartment, comes into the room. He's yelling "What the f*** is going on?" She jumps up naked then grabs the covers away from me—also naked. Just a crazy situation.

DESCRIBE YOUR FANTASY DATE: Starting with roses all over my apartment. I have wine, silk sheets, and airplane tickets. I love romance. I believe the essence of romance is surprise. My fantasy date would be a night of passion, relaxation, and excitement.

WHAT DO YOU DO FOR FUN? I do almost everything for fun. I love skating when I'm just bored. Or talking to friends. But what I really enjoy is rock-climbing or Southern Shaolin Kungfu. I'm very athletic, so almost anything active is agreeable to me.

DO YOU PLAY ANY SPORTS? DESCRIBE YOUR ATHLETIC ABILITY: I surf, rock-climb, skate, wrestle, run long distance, and practice martial arts. My athletic ability is focused on balance and unifying the mind and body with precise movements. I'm not really focused too much on power or speed. I focus on technique.

WHAT ARE YOUR FAVORITE MUSICAL GROUPS/ARTISTS? I'm really into underground hip-hop groups like Freestyle-Fellowship and Company Flow. Mainstream artists like Outkast, Alicia Keys, and Aaliyah (rest in heavenly peace).

DESCRIBE A TYPICAL FRIDAY OR SATURDAY NIGHT: Well, being in a band our weekends are pretty full with playing shows. So typically we're in the reggae scene on Friday and Saturday nights. There is always after parties at some club or bar so we meet people and mingle. A lot of times we're just rushing from one set to another.

DO YOU LIKE TRAVELING? DESCRIBE ONE OR TWO OF THE BEST OR WORST TRIPS YOU HAVE TAKEN: The best/worst trip ever was with my friend Jonathan and my puppy Lars in San Francisco. We decided to drive up North and squat for a few days. All in the course of one day we ran out of gas and had to hoof it 4.5 miles to get gas. We had our truck towed away with Lars in it. We almost got car-jacked and half-way

DESCRIBE YOUR CHILDHOOD: My childhood was one of dreams and adventure. I have a large family that's really close, the type that gets together every Sunday. My childhood was one with a solid religious foundation, which was good because it helped me grasp the concept of losing loved ones early on. Being from such a large family it seemed as if someone was always passing on. Those losses only added to my passion for living to the fullest. My childhood was perfect, I wouldn't change the good or bad.

DESCRIBE A MAJOR EVENT OR ISSUE THAT'S AFFECTED YOUR FAMILY: The death of my little brother was the test that's altered our family in so many ways. It has made us stronger individuals as well as a stronger family unit. We all were put in perspective and the time spent together even just eating or watching TV became precious. It still isn't easy, and we'll never forget Jonathan. But we've proven that as a family we can endure anything.

home realized we didn't have enough money to make the drive home.

WHAT ARE SOME WAYS YOU HAVE TREATED SOMEONE WHO HAS BEEN IMPORTANT TO YOU THAT YOU ARE PROUD OF? My mom—I've always treated her with respect even when she's wrong. I've always been extremely honest with her—too honest for her sake in some cases. But that's how close I feel our relationship is. I'm proud that not only do I love and respect my mom she's also my closest friend.

HAVE YOU EVER TREATED SOMEONE WHO IS IMPORTANT TO YOU IN A WAY THAT YOU NOW REGRET OR ARE EMBARRASSED BY? I regret ignoring (to some degree) my little brother Dennis. Our relationship has totally changed since I moved back home. I see my little bro in a new light now. Before he was this naggy little creature with far too much energy. Now it's like we're on the same page even though he is still ten years younger. I guess my regret is just for time lost.

HEARD IN CASTING

"LIVING IN LAS VEGAS WILL BE A BEAUTIFUL EXPERIENCE. LAS VEGAS IS SUCH A DIVERSE TOWN—SO MANY DIFFERENT PEOPLE ARE THERE. I'LL JUST BE ABLE TO LEARN SO MANY DIFFERENT THINGS. I'LL PROBABLY GET IN A LITTLE TROUBLE IN LAS VEGAS, BUT GOOD TROUBLE."

WHO ARE YOUR HEROES AND WHY? Jesus is my hero. He was so cool. He had all the power in heaven, yet his discipline and resolve kept him on his life mission. Superman has similar character traits. He had powers that could make him filthy rich yet he chose to be Clark Kent for himself and Superman for everyone else.

WHAT ARE YOUR THOUGHTS ON PEOPLE WHO HAVE A DIFFERENT SEXUAL ORIENTATION THAN YOU? I'm cool with that. I was in a play where almost the whole cast was homosexual except me and my mom. It was weird at first until I realized they're just people and their sexual habits are not affecting me.

WHAT ARE YOUR THOUGHTS ON INTERRACIAL DATING? Love is blind!

DO YOU HAVE ANY HABITS WE SHOULD KNOW ABOUT? I have been called a compulsive laugher. I have a habit of goofing off.

WHAT BOTHERS YOU MOST ABOUT OTHER PEOPLE? Dishonesty and disloyalty. It really bugs me to rely on someone and find them unreliable when you need them most.

IF YOU COULD CHANGE ONE THING ABOUT THE WAY YOU LOOK, WHAT WOULD IT BE? I would be a little taller with wings and big teeth and red eyes that change colors. Joking! Seriously, if I could change the way I look, I think I'd have big long nails that curl like the Viper at Magic Mountain.

IF YOU COULD CHANGE ANY ONE THING ABOUT YOUR PERSONALITY, WHAT WOULD IT BE? It would probably be a lot more discipline. I tend to float to and fro. I would want a structure-based personality. Right now I'm just good at what I do. With discipline along with my natural talent I could be great.

IF YOU HAD ALADDIN'S LAMP AND THREE WISHES, WHAT WOULD THEY BE? I would wish to be a billionaire. I would wish to witness completely what happens once you die. I would wish to meet my perfect girl.

DESCRIBE A QUALITY/TRAIT THAT RUNS IN YOUR FAMILY: Our family is extremely spiritual. We have an easygoing nature and that helps us to stay patient. The most dominant character trait would have to be a no-rush attitude on life. We are comfortable though not materialistic. But spirituality is the root, the rest is the fruit.

WHAT IS THE MOST IMPORTANT ISSUE OR PROBLEM FACING YOU TODAY? That would be getting my bills paid and getting serious about school. Everything else will come in its own time.

IF I COULD CHANGE THE WAY I LOOK, I THINK I'D HAVE BIG LONG NAILS THAT CURL LIKE THE VIPER AT MAGIC MOUNTAIN.

WHY ALTON WAS CAST

WHAT BROUGHT YOU TO **THE REAL WORLD**? I broke up with my ex-girlfriend and moved from L.A. back to San Diego. I was at my aunt's right after that, talking to her about everything. I was very down—crying in her lap and being a big baby. At one point, my aunt turned on the TV and there was an advertisement for an open call for a show called *Love Cruise*. It said, "Are you single?" My aunt said that I should do it, but I was like, "No way." She said, "Boy, you better get out of my lap and write that number down!" So I got her a pen and paper and she wrote the number down. I went, and I made finalist...but they did not go forward with a second season. The people involved called me for *The Real World* instead.

ALTON: I have no idea why I was chosen. I guess I was lucky. I do a lot of things—I skate, surf, rock climb, play violin. I suppose that's kind of interesting and I have an interesting past. A lot of crazy stuff happened in my life.

MARY-ELLIS BUNIM: Alton also has an interesting performing background. We thought his playing the violin was very appealing and an interesting contrast to the type of performance that goes on in Las Vegas.

JONATHAN MURRAY: We met Alton six or seven months before *Real World* casting. We were casting another show and he popped up on our radar screen and that show ended up not going forward. So we kept him in mind and continued to get to know him. The first thing that always strikes me about Alton is his smile—it lights up the room. He also has a really interesting back story in terms of the tragedy that happened in his family and the murder of his brother.

DR. LAURA KORKOIAN: Alton is a very loving man. He loves his family, and is hurting so deep inside from the pain of losing his brother. We needed someone like that in the house, who has a connection to family. Also, knowing that Trishelle had to deal with the loss of her mom, we thought there may have been an opportunity for the two of them to talk and learn how to talk about death. It's a really relatable issue. There are people out there who've lost loved ones who maybe would see something in Alton that would help them in their own process of moving on.

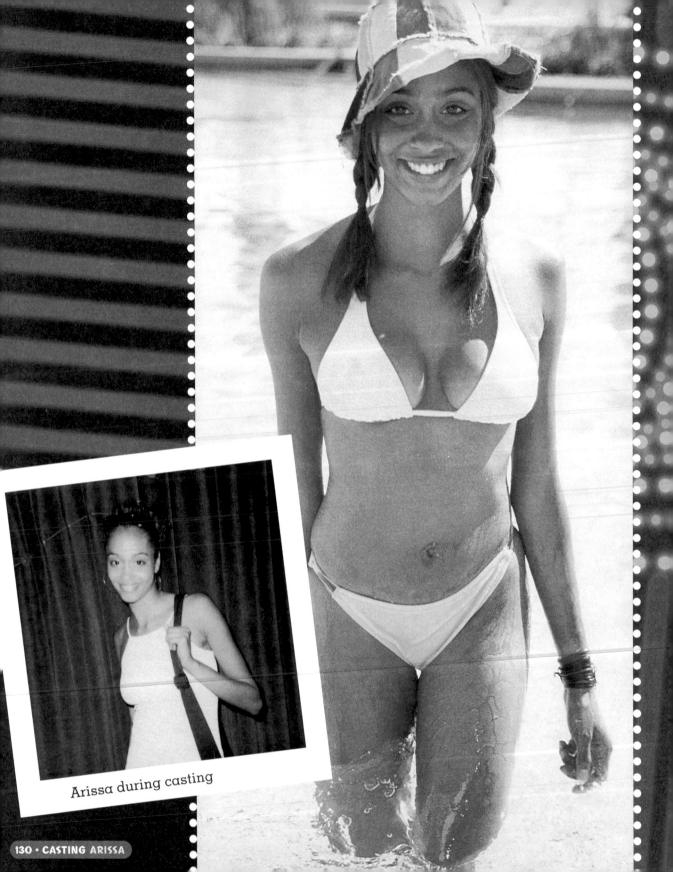

Arissa during casting

Arissa

NAME: Arissa

AGE: 22

BIRTHDAY: April 29

PRESENTLY LIVING IN: Malden, MA

PARENTS: Karen

SIBLINGS (NAMES AND AGES): Jenna

WHAT IS YOUR ETHNIC BACKGROUND?: American Indian, Black, Italian

NAME OF HIGH SCHOOL: Fenway Middle College High School

NAME OF COLLEGE: Johnson & Wales University (2 years), Business Major

WHERE DO YOU WORK? DESCRIBE YOUR JOB HISTORY: I work at an accounting firm. My job history is erratic—I don't know what I want from life yet.

WHAT IS YOUR ULTIMATE CAREER GOAL? Ultimately I want to be filthy rich and I want the world to worship me :)

WHAT KIND OF PRESSURE DO YOU FEEL ABOUT MAKING DECISIONS ABOUT YOUR FUTURE? WHO'S PUTTING THAT PRESSURE ON YOU? I have serious pressure issues from family, mainly my stepfather and mom. They think I'm irresponsible. They don't like what I like for myself.

WHAT ARTISTIC TALENTS DO YOU HAVE? HOW SKILLED ARE YOU? I write poetry, freestyle. I am very skilled at this. I also cook really well.

WHAT ABOUT YOU WILL MAKE AN INTERESTING ROOMMATE? I might be crazy. I never bite my tongue, so sometimes that's cause for drama. I have been raised an only child so I have never shared space with anyone but my mom and she was never around once I hit 16. Even in college I had my own dorm room.

HOW WOULD SOMEONE WHO REALLY KNOWS YOU DESCRIBE YOUR BEST TRAITS? I am funny. I am down to do anything. I am never embarrassed. I am spontaneous. I am crazy (in a good way). I have a thick skin—no wait, that's a lie. I am nice to everyone unless they are an a**hole.

HOW WOULD SOMEONE WHO REALLY KNOWS YOU DESCRIBE YOUR WORST TRAITS? I can be a f****** bitch. I have a bad temper. I hate a**holes and people who think they are too smart. I am lazy. I can't spell for shit.

DESCRIBE YOUR MOST EMBARRASSING MOMENT IN LIFE: My first time skiing I thought I could do the hardest slope after two private lessons. Wrong. I kept crashing into trees and people so I took off my skis and walked down the mountain. It took two hours. I put skis back on to ski down the rest—I crashed into everyone (including the guy I was trying to impress) then hit the ski lodge window. The jig was up after that.

DO YOU HAVE A BOYFRIEND OR GIRLFRIEND? HOW LONG HAVE YOU TWO BEEN TOGETHER? WHERE DO YOU SEE THE RELATIONSHIP GOING? I have a boyfriend—for five years. Maybe marriage. He is an a**hole and gets belligerent when he's drunk. But he's so sweet and nice and handsome and put up with my insanity for so long and he's so damn funny.

WHAT QUALITIES DO YOU SEEK IN A MATE? He needs to be funny, spontaneous, beautiful. Put together. (Me as a male).

HOW IMPORTANT IS SEX TO YOU? DO YOU HAVE IT ONLY WHEN YOU ARE IN A RELATIONSHIP, OR DO YOU SEEK IT OUT AT OTHER TIMES? Sex is very important. I only have it in a relationship. I have been in the same relationship for five years. *Can't survive without sex!* (I might have a problem).

DESCRIBE YOUR FANTASY DATE: Me and him, a hotel room, video camera, handcuffs, champagne.

WHAT DO YOU DO FOR FUN? Everything—i.e., playing dominoes, reading, writing, drinking, sex—you can't forget sex.

DO YOU PLAY ANY SPORTS? DESCRIBE YOUR ATHLETIC ABILITY: Yes—I play touch football and pickup basketball.

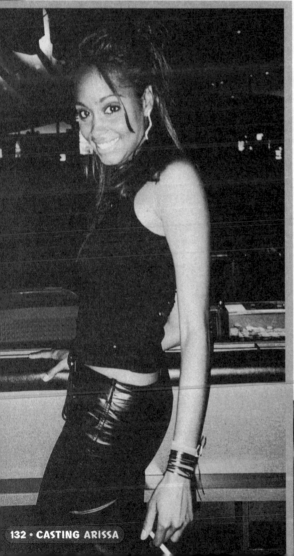

WHAT ARE YOUR FAVORITE MUSICAL GROUPS/ARTISTS? Outkast, Jay-Z, Alicia Keys, Red Hot Chili Peppers, Dave Matthews, Billie Holiday, Miles Davis.

DESCRIBE A TYPICAL FRIDAY OR SATURDAY NIGHT: Out with the man drinking then home to have sex or out with the girls drinking then home to have sex.

WHAT ARE SOME WAYS YOU HAVE TREATED SOMEONE WHO HAS BEEN IMPORTANT TO YOU THAT YOU ARE PROUD OF? I give the shirt off my back to anyone in my life. I also listen when people talk. Impromptu therapy.

HAVE YOU EVER TREATED SOMEONE WHO IS IMPORTANT TO YOU IN A WAY THAT YOU NOW REGRET OR ARE EMBARRASSED BY? Hell, yes!! I treat my boyfriend like s**t. Sometimes I am a hot head and little simple things get to me. Like if you will be late, just call or please don't patronize me, it makes me crazy and I punish him for it. It's not too nice. But I will make up for it always. I really hate my temper.

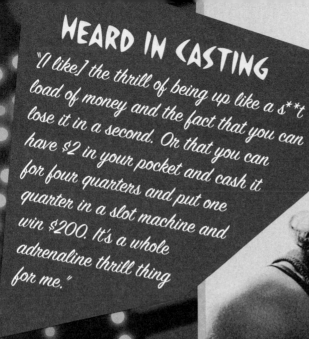

HEARD IN CASTING

"[I like] the thrill of being up like a s**t load of money and the fact that you can lose it in a second. Or that you can have $2 in your pocket and cash it for four quarters and put one quarter in a slot machine and win $200. It's a whole adrenaline thrill thing for me."

OTHER THAN A BOYFRIEND OR GIRL-FRIEND, WHO IS THE MOST IMPORTANT PERSON IN YOUR LIFE RIGHT NOW? My dog :) No, my great-grandma. She's 90 and she's a hot s**t.

DESCRIBE YOUR CHILDHOOD: It sucked.

WHAT IS THE MOST IMPORTANT ISSUE OR PROBLEM FACING YOU TODAY? Life.

WHAT ARE YOUR THOUGHTS ON PEOPLE WHO HAVE A DIFFERENT SEXUAL ORIENTATION THAN YOU? Nothing—it's fine to me.

WHAT ARE YOUR THOUGHTS ON INTERRACIAL DATING? I'm biracial—what do you think?

DO YOU HAVE ANY HABITS WE SHOULD KNOW ABOUT? I smoke cancer sticks, drink gin and whiskey.

DESCRIBE YOUR FANTASY DATE:

ME AND HIM, A HOTEL ROOM, VIDEO CAMERA, HANDCUFFS, CHAMPAGNE.

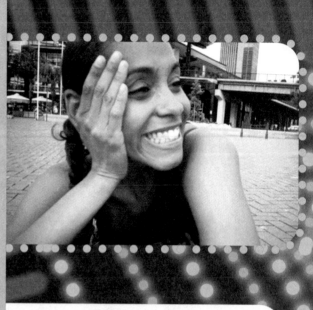

cations are they going to go through? So I didn't deal with it. I didn't send a tape and I didn't send an application. A week later, they called and asked if I sent the tape. I hadn't but I realized they must be serious about me if they called. So all of a sudden I was rushing around, getting a camera, getting a tape, and filling out that huge application. I would write one-word answers like No. Yes. Surprisingly, they called me in December, and told me I was a semifinalist.

I went to New York for interviews. A couple of weeks later they called me for the finals, and I went through them. Three days later they called me and told me I needed to be in Las Vegas in three days. It was so quick I didn't even process it. But I wanted to do it for so many reasons. I wanted to communicate the way that I feel about so many situations. I wanted to learn about me. I wanted to teach other people about things they may or may not know. I wanted to just experience something that I wanted to be a part of since I was 12 years old.

WHAT BROUGHT YOU TO THE REAL WORLD? I went to an open call for another show. I made the finals for that show and then I got a phone call that said, "We're sorry but the show is not going forward. But we'll keep you in mind for anything else." I was really disappointed and this was in August. By October I got a phone call asking, "How would you like to try out for *The Real World*?" I was like, "Are you s******* me? Are you kidding?" They told me to send a tape and to send another application. All my hopes deflated right there because I started to think—how many appli-

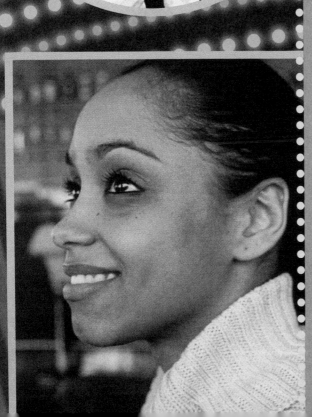

ARISSA: I think they cast me because they found out I was a mental case! No, really, I think they choose people that they feel are interesting. And I guess I was interesting.

MARY-ELLIS BUNIM: Even in casting, Arissa's evolution was one of the most interesting. Although we originally found her for another production, we recognized that her background and appeal were very right for *The Real World*. Arissa is the kind of girl who is willing to take on a challenge.

JONATHAN MURRAY: Arissa has an interesting background as she grew up in the projects, and I think she's had a lot of people turn their backs on her, which has created real trust issues. It's always interesting to put someone like that into *The Real World* environment because they are forming a new family. And for someone like Arissa it takes a while for her to have trust with someone that she is living with.

DR. LAURA KORKOIAN: During casting I liked the way in which Arissa would give it right back to the interviewer. She took no crap from them and would put the question right back on them sometimes. She comes off as a tough girl who can take care of herself, and I admired that about her. But when I looked beyond her defenses, I got to the vulnerable side of Arissa, and her ability to show some pain, talk about what's going on in her past, and understand how her past is keeping her stuck in some ways. This was a great opportunity for Arissa to get away from Boston and to learn about herself and figure out where she's going and what she wants. She's beautiful, she's sassy, and there's a strength to her, but she also has this very precious vulnerability.

Frank during casting

NAME: Frank

AGE: 22

BIRTHDAY: July 25

PRESENTLY LIVING IN: Lewisburg, PA

PARENTS: Karen and Howard

SIBLINGS (NAMES AND AGES): Jane, 36—half sister and didn't live with me

WHAT IS YOUR ETHNIC BACKGROUND? Caucasian

NAME OF HIGH SCHOOL: Lewisburg High School

NAME OF COLLEGE: Bucknell University, 4 years, Electrical Engineering

WHERE DO YOU WORK? DESCRIBE YOUR JOB HISTORY: I've had several internships for electrical engineering, however, most of my life I've worked at my dad's pizza shop.

WHAT ARTISTIC TALENTS DO YOU HAVE? HOW SKILLED ARE YOU? I am not artistically inclined whatsoever. However, once I set fire to my grade school art room while attempting to burn a pot.

WHAT ABOUT YOU WILL MAKE AN INTERESTING ROOMMATE? I grew up in a town of 5,000, in a high school of 380 students. I then went to college in that town, Bucknell. This school is comprised of 3,300 white, upper-middle class students, all of whom pretend to be open-minded yet none of whom have actually spoken to a black, Jewish, bisexual, or gay person before. Yes, I pretty much fit this bill as well. This nondiverse lifestyle has, unfortunately, left me very close-minded. However, in combination with my flare for argument and bluntness I'm bound to put my foot in my mouth multiple times a day.

HOW WOULD SOMEONE WHO REALLY KNOWS YOU DESCRIBE YOUR BEST TRAITS? No matter the circumstances surrounding my life I'm able to mask it with an appearance of glee and enjoyment. I was voted class clown of my graduating class last year, and I think I was generally one of the saddest kids. I can somehow turn all this bubbling depression and anger into sarcasm and humor. I think this makes me an enjoyable person to be around.

HOW WOULD SOMEONE WHO REALLY KNOWS YOU DESCRIBE YOUR WORST TRAITS? I sometimes show little regard for others' feelings if they have an opposing view. I need to have more patience with people who can't handle my lifestyle, in that if someone lightly criticizes a decision I make, I take high offense. When people first meet me, I'm too "my way or the high way."

DESCRIBE YOUR MOST EMBARRASSING MOMENT IN LIFE: The fork of my life; May 1, 2001, me and my best friend got dramatically intoxicated after completing a very difficult midterm. I'm not sure why, but when I'm drunk and around him I sometimes act like a jackass. To make a long story very short, we tore out a few toilets from the ground and broke a few deadbolts. This is completely atypical of my personality. I have never gotten in a fight in my life, nor am I prone to violence. Having said that, this was a stupid, regretful act of youth and angst. I am not embarrassed of this, I am embarrassed at the situation it threw my life into. We were tackled, arrested, and thrown in jail on $50,000 bail. The arresting officer seemed somehow proud of himself, as he nonchalantly charged us with two felony counts, two misdemeanors, and a summons.

This uneducated ignoramus took advantage of the situation I put myself in, and took out all of his own life's regrets and jealousies by ruining mine. The news was out in my cardboard box-sized town before they had time to take mug shots of me. In a matter of less than five minutes, I changed my life forever. This situation has obviously affected me much deeper than I can express on this paper. Suffice to say, my innocent, successful, proud life has been challenged in a way I never imagined. Incidentally, months later the felonies were dropped, but I still have a misdemeanor criminal record now and I got a 98% on my midterm.

DO YOU HAVE A BOYFRIEND OR GIRLFRIEND? HOW LONG HAVE YOU TWO BEEN TOGETHER? WHERE DO YOU SEE THE RELATIONSHIP GOING? Technically I'm single. I broke up with my girlfriend of three years in July. However we still talk to each other almost daily and try to pretend, that, though we're still sleeping together, we're just friends. I love her and I'm in love with her. However, I broke up with her because things were going too well. I realized I'm 22 and that I need to live my life before I can dedicate it to someone.

WHAT QUALITIES DO YOU SEEK IN A MATE? Physical attraction! Also, it's important that she is completely in love with me if we're committed. I can't handle dating a friend.

HOW IMPORTANT IS SEX TO YOU? DO YOU HAVE IT ONLY WHEN YOU ARE IN A RELATIONSHIP, OR DO YOU SEEK IT OUT AT OTHER TIMES? I live for the act of sex. I'm sitting on the edge of disaster at the moment. I've only had a few sexual partners because I've been in a relationship for the past 3 years. Now that that's over I'm thinking I might go buck wild for a few years, until I'm sick of it. I loved my last sexual encounter. I was at a party with a girl with whom I had a one-night stand. Later that night I had sex with her roommate in the bathroom. The first girl found out about it, but still had sex with me. I'm not sure why she did, but it made for an

WHEN PEOPLE FIRST MEET ME, I'M TOO "MY WAY OR THE HIGH WAY."

enjoyable evening. I would love to try to blend this into a ménage à trois but I think I would chicken out as this would officially turn me into Porno Man. I'm not sure I can handle that all the time. I like my morals.

DESCRIBE YOUR FANTASY DATE: It has to be with someone I've had a crush on for a long time, but whom I never thought I could get. It's July and a beautiful day in the country. We go for a walk behind my house which leads into the wilderness and lots of farmland. The whole time I can't believe that she's here with me and that she actually finds me funny. We explore for a couple of hours, and then come across an empty barn. She takes a couple of steps in and begins to talk about how this place must have been passed down from one generation to the next. I can no longer control my desire as I passionately wrap my hands around her stomach and shoulder from behind. She tilts her head back and looks up at me just in time for the kiss. We make love there on the hay and the whole time I'm just thinking about how right now, no one else exists in the world but us.

WHAT DO YOU DO FOR FUN? I go out to parties a lot, but this isn't "fun" to me. What I enjoy the most are those two or three hours before me and my friends go out. We're all just hanging out, drinking, and having the time of our lives. It's these moments I'm going to miss, not the hookups or parties that happen along the way.

DO YOU PLAY ANY SPORTS? DESCRIBE YOUR ATHLETIC ABILITY: I unsuccessfully played baseball, basketball, and soccer in high school. After realizing that I have the coordination of a one-eyed albatross, I gave up on sports involving skill and joined the track team. I'm extremely athletic and uncoordinated.

WHAT ARE YOUR FAVORITE MUSICAL GROUPS/ARTISTS? Outkast, Linkin Park, Gwen Stefani, Ice Cube, Alien Ant Farm, Jay-Z, Usher, Busta Rhymes, Puddle of Mudd, lots of random techno, blink-182.

DESCRIBE A TYPICAL FRIDAY OR SATURDAY NIGHT: This would involve me and three of my friends starting to drink at 6:30 with *Kingpin* on in the background. At 8:15 *Kingpin* has ended and so has our sobriety. We throw Jay-Z into the disc changer and Goldschlager in our mouths. After laughing, wrestling, and singing for two hours, it's time to go out to the frats. Now we split up and try to dance, or hook up with every attractive—relative to the blood-alcohol level—girl that we can. One of us embarrasses himself by singing along with the band, one of us goes home with a girl, one of us passes out in a room he's never been in in a fraternity he doesn't belong to, and one of us stays up until 6 A.M. drinking with four other guys doing the same thing.

WHAT ARE SOME WAYS YOU HAVE TREATED SOMEONE WHO HAS BEEN IMPORTANT TO YOU THAT YOU ARE PROUD OF? When I was arrested with my 250-pound roommate, they noticed an obvious size difference and separated us into two interrogation rooms. They told me they wouldn't charge me with the felonies if I said he was the major contributor. Needless to say, I got the felonies and I kept my best friend.

WHO IS THE MOST IMPORTANT PERSON IN YOUR LIFE RIGHT NOW? I know this sounds pathetic, but it's my wife. I haven't met her yet, but I think about her all the time. I wonder where she is and if she's thinking about me. I also keep her in mind with most of my major life decisions. I'm working as hard as I can to give the two of us a better life when we do meet.

DESCRIBE YOUR CHILDHOOD: Damn near perfect. I grew up in a suburb in the middle of nowhere. Everyone knew all their neighbors and would welcome newcomers with fresh pies. My parents spoiled me with love and adoration. In grade school my house was where every cool kid would play tag. Then it turned into the place where all the high school kids would go to hang out. My childhood could not be filled with more memories of fun and enjoyment. It sculpted me into who I am.

DESCRIBE A MAJOR EVENT OR ISSUE THAT'S AFFECTED YOUR FAMILY: My father owns a small pizza shop in our small town. It's really a ma-and-pa type store out of some novel. Every day after school all the kids gather there and you can see the enormous joy it gives my parents to feed them. One year after a huge winter of snow storms, downtown was flooded and my father's shop was most seriously affected. The entire basement full of supplies and inventory was under water. For about six or seven hours he and I worked on getting the water out and separating the ruined from the salvageable. At the normal time that all the kids would come over, they saw the massive amount of damage upon arrival. As if repaying my father for all the memories, every single kid was getting muddy with the two of us and doing what they could. This near tragedy was probably the best memory my parents have of that shop.

DESCRIBE A QUALITY/TRAIT THAT RUNS IN YOUR FAMILY: Intolerance and humor. I got these both from my dad. I don't think anything gives him more joy than when the McDonald's people forget the ketchup packet. He blows into a fit of anger and I really think he enjoys it. I don't care about ketchup, but he gave me this trait in other aspects of my life.

WHAT IS THE MOST IMPORTANT ISSUE OR PROBLEM FACING YOU TODAY? GETTING INTO A TOP-RANKED GRAD SCHOOL! I'm right now in the middle of filling out grad essays and statements of purpose. I took my GMATs and got a 710 on them. I'm taking my GREs in two days and I'm overloading myself with studying deadlines and now the *Real World* application. Nothing I can't handle, though.

WHO ARE YOUR HEROES AND WHY? My father kicks ass! I worship him for his accomplishments. His mother died when he was 13, his father neglected him, and his other relatives were drunks. He turned his life into a positive by becoming a cop in Harlem for eighteen years, owning several small businesses, and having a perfect family.

WHAT ARE YOUR THOUGHTS ON PEOPLE WHO HAVE A DIFFERENT SEXUAL ORIENTATION THAN YOU? I want so much to say I'm comfortable around them. But every time I see two guys kissing it makes me cringe.

WHAT ARE YOUR THOUGHTS ON INTERRACIAL DATING? I hope to indulge in that one day, though so far it has eluded me. The bitchiness of black chicks just makes me want to hook up with one.

DO YOU HAVE ANY HABITS WE SHOULD KNOW ABOUT? I work out every day and try to eat healthy. Other than that I am a work-social life-aholic.

WHAT BOTHERS YOU MOST ABOUT OTHER PEOPLE? I really hate it when people take what I'm saying too seriously. I know my opinions are a bit offensive but they should all be taken with a grain of salt. When people get upset with things I say, it just makes me want to get them more mad for not having the insight to truly see what I was saying. This personality trait of mine probably gets me in the most trouble.

IF YOU COULD CHANGE ONE THING ABOUT THE WAY YOU LOOK WHAT WOULD IT BE? All my friends make fun of me for having a longer than average neck. I think they're just jealous because I can eat the apples off the tops of the trees and they can't.

IF YOU COULD CHANGE ANY ONE THING ABOUT YOUR PERSONALITY WHAT WOULD IT BE? After all this felony stuff happened to me I lost my innocence and optimism. I didn't have a care in the world and I was loving life. That's what I hope to find again if I'm selected. I want my happiness back.

IF YOU HAD ALADDIN'S LAMP AND THREE WISHES WHAT WOULD THEY BE? First, I would wish for my old life back. Second, I would wish for my mother to have her rheumatoid arthritis go away. Third, I would wish that no matter what happens I will meet my perfect mate someday and spend the rest of my life with her.

WHAT BROUGHT YOU TO THE REAL WORLD? I wanted some more excitement, adventures, stories to tell like my dad. That's probably why I auditioned for *The Real World.* Just for another story.

WHY FRANK WAS CAST

FRANK: I don't know why I was cast. I feel like everyone in America is going to see me and be like, "He shouldn't be on *The Real World.* That guy slipped through the cracks."

MARY-ELLIS BUNIM: Frank is somebody you relate to. He's a kid from central Pennsylvania who really hasn't been anywhere, though he is a college graduate. And he's a smart guy, but he just hasn't had a lot of life experience.

JONATHAN MURRAY: Frank's booming voice is funny but at the same time kind of geekish, but he's so smart and articulate.

DR. LAURA KORKOIAN: I hadn't met somebody like Frank in a long time. He's so intense. But I didn't know if I should be taking him seriously or if he was acting for me at first. There's such an intensity and a passion in him. When he auditioned for *The Real World,* he was at a place in his life where he wasn't very happy. For half of the interviews he looked down, he never gave direct eye contact. He was just not happy in his life. He was looking for change, and a chance to have some fun, and not have to be so responsible, serious, and intense. He's a great narrator, too, and sort of the missing link between Alton and Steven. He was sort of a voice, overall, telling us what was going on in the house. It's been great to watch Frank evolve—he's got his direct eye contact down. He's happy again, he's focused on where he's going with his future. It's very rewarding. For him—and certainly for all of us.

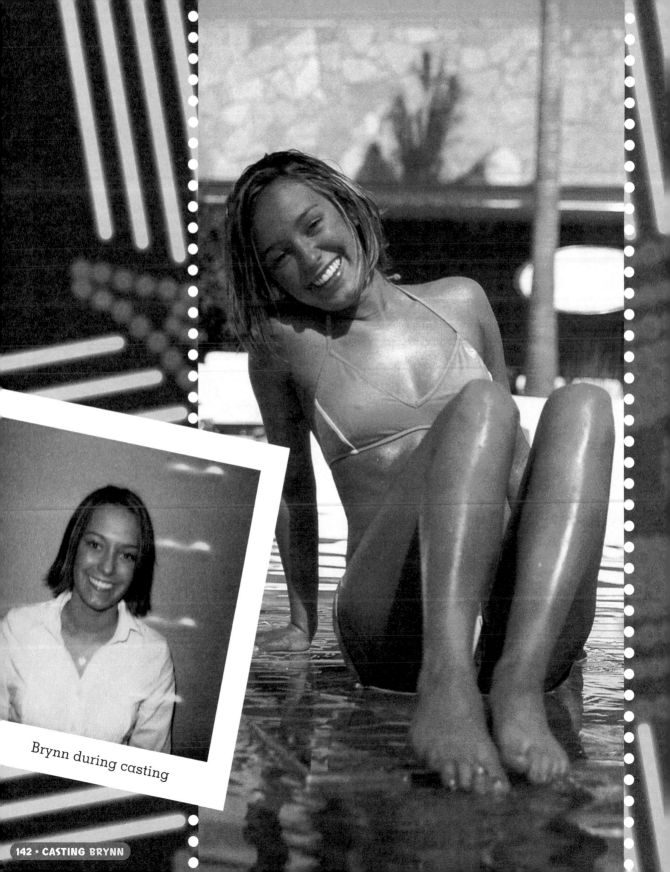

Brynn during casting

CASTING Brynn

NAME: Brynn

AGE: 20

BIRTHDAY: November 22

PRESENTLY LIVING IN: Portland, OR

PARENTS: Kim and Doug

SIBLINGS (NAMES AND AGES): Jennifer, 18, Allison, 23.

WHAT IS YOUR ETHNIC BACKGROUND?: Caucasian

NAME OF HIGH SCHOOL: Raymond High School

NAME OF COLLEGE: Concorde Career Institute (Certified Dental Assistant)

WHERE DO YOU WORK? DESCRIBE YOUR JOB HISTORY: I am currently dental assisting and looking for a second job. I have served at restaurants for almost four years. I took high school photographs, was assistant manager of Mr. Rags clothing store. I've also been an exotic dancer (just joking!).

WHAT ARTISTIC TALENTS DO YOU HAVE? HOW SKILLED ARE YOU? Dancin'. I love to dance. I'm pretty sure I've got some rhythm, too. But there was this one time when I was interviewing for *The Real World* and these guys surrounded me with a boom box and made me dance in front of a video camera to J.Lo when I was really hung-over. Now that's pressure! I like to write short stories and poems as well. I haven't done any in a while though.

WHAT ABOUT YOU WILL MAKE AN INTERESTING ROOMMATE? Well, let's see, I like to cook, so that's good. I hate to clean, so that's bad. I like to party, good. Stay up late and talk, good. Be loud and crazy, good and bad. I love to sleep with someone as long as I'm not alone. I have bad dreams sometimes, so it's comforting to sleep with someone, plus it's just plain warm. I hate laundry. I like to wrestle. I get silly-nutty in my pjs. I hate mornings and I especially hate people who love mornings. I like to argue. I burp really loud. I'm very open. I sleep naked. I take really long showers. I pee with the door open. I'm fun and crafty. Heck, I'm just really great and awesome to live with!

HOW WOULD SOMEONE WHO REALLY KNOWS YOU DESCRIBE YOUR BEST TRAITS? I think they would say I have a good heart, that I'm a genuinely good person, intelligent and I'm bomb. I'm outgoing. Should I go on? Okay, anything I do or anywhere I go I make a damn good time out of it and I'm just plain funny.

HOW WOULD SOMEONE WHO REALLY KNOWS YOU DESCRIBE YOUR WORST TRAITS? I'm moody, indecisive, procrastinator, and a whiny little brat. I'm horrible at keeping a secret and I'm a really big smartass. I'm possessive and I can be a big bitch. I'm a little selfish, too.

DESCRIBE YOUR MOST EMBARRASSING MOMENT IN LIFE: I don't get embarrassed easy but I do have a classic "Brynn" moment to spill. This one time in Mexico, I had met this really hottie scuba instructor named Brad. Well, Brad took me out to a bar known as the Zoo. Well, when you walk into this bar you step up about four marble steps and off to the right of the second step is a bar to sit at. Brad and I sit there and consume a few beverages and then he asks me to dance. So I'm standing on one of the steps waiting for Brad. I forget

I'm standing on a stair. I take a step back, fall on my booty, my legs go up into the air. Did I mention I had a short dress on? Needless to say, there were about twenty hot Latino boys standing in close proximity who all got a shot of my panties, but I rebounded with a Mary Catherine Gallagher pose and everything was fine.

DO YOU HAVE A BOYFRIEND OR GIRLFRIEND? HOW LONG HAVE YOU TWO BEEN TOGETHER? WHERE DO YOU SEE THE RELATIONSHIP GOING? Do I have a boyfriend? Well, if you ask one of my friends they would probably say "Your guess is as good as mine." Brendan and I have been together off and on for two years now. Every other week we break up. We've lived together for a year and a half of our relationship and since July I've lived with my friend Natalie and I've dated other people. I can't tell the future of our relationship, it's ever changing. Brendan's attitude drives me crazy, he is always upbeat, never mad or sad. It's like he's on repeat, he also has a tendency to be immature around other guys. But what drives me crazy drives me mad happy because he is so emotionally stable it kind of balances me out.

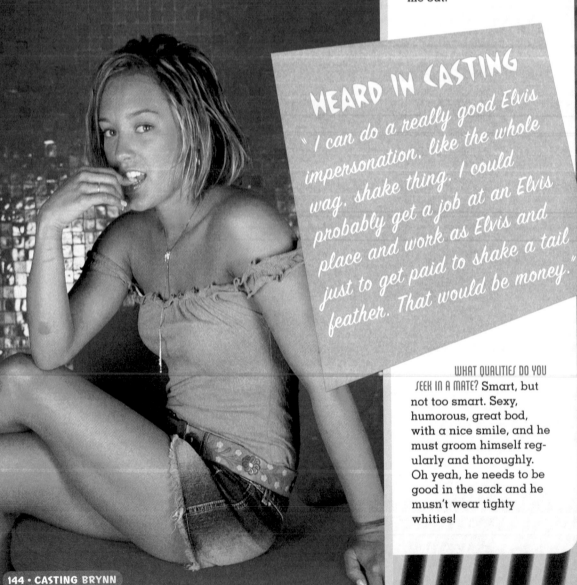

HEARD IN CASTING

"I can do a really good Elvis impersonation, like the whole wag, shake thing. I could probably get a job at an Elvis place and work as Elvis and just to get paid to shake a tail feather. That would be money."

WHAT QUALITIES DO YOU SEEK IN A MATE? Smart, but not too smart. Sexy, humorous, great bod, with a nice smile, and he must groom himself regularly and thoroughly. Oh yeah, he needs to be good in the sack and he musn't wear tighty whities!

HOW IMPORTANT IS SEX TO YOU? DO YOU HAVE IT ONLY WHEN YOU ARE IN A RELATIONSHIP, OR DO YOU SEEK IT OUT AT OTHER TIMES? Sex is semi-important. Of course, I like it, but the guy has to really make me like it. Keep me on edge. I have sex whenever I want it both in and out of my relationships. I don't think I seek it out but when I meet a guy I know within fifteen seconds if I would sleep with the guy or not. Well, it's been a few days, which is kind of unusual but I think I was at Brendan's house and he was in the shower and his shower curtain is see-through and no one was home and well, I think you get the picture.

DESCRIBE YOUR FANTASY DATE: Well, again, I've never actually been on a "true date." I would like it to be drinks, dinner, more drinks, dancing, so I can scope the motion in the ocean. And some cute little gift, something unique, that says, "You're cute, I like you."

WHAT DO YOU DO FOR FUN? Fun, fun is my middle name. I go out dancing and clubbin', I like to play pool and video crack (though I suck). I like to go to dinner and dancing and more food and drinks and dancing and sometimes I like to just chill with my friends Ben and Jerry and do makeovers. Fun, fun.

DO YOU PLAY ANY SPORTS? DESCRIBE YOUR ATHLETIC ABILITY: Is pool a sport? I used to be athletic. I even used to workout and then I met lazy and I really like it. I am however planning to rejoin a health club or start yoga as soon as I become rich.

WHAT ARE YOUR FAVORITE MUSICAL GROUPS/ARTISTS? I like mostly everything except country. I do, however, love the 80s, New Kids on the Block, Milli Vanilli, Color Me Bad, etc.

DESCRIBE A TYPICAL FRIDAY OR SATURDAY NIGHT: Well, right now funds are kind of tight, so I have been relying on the good old plastic which is about to be maxed out. So my weekends have been somewhat low-key. My roommate's boyfriend is a bartender so we usually go to his bar and drink, play pool, and BS. There is no dancing there. Since we both share an ID, our nights are usually not spent together, so if she calls dibs on the ID I usually get stuck at Brendan's to drink beer and play Nintendo. But since my 21er is in twelve days my nights will once again be filled with dancin' and romancin'.

WHAT ARE SOME WAYS YOU HAVE TREATED SOMEONE WHO HAS BEEN IMPORTANT TO YOU THAT YOU ARE PROUD OF? I think I've treated my father very well. Ever since he came out of the closet he's been a little bit more emotional. He's been through many trials and tribulations with his family, his daughters and his lovers and I've been there for him through it all, to listen and share my opinion and encourage him to tough it out, grow some balls and be a man, a gay man, that is. I love my dad with all my heart. He is very special and I praise him for what he's done.

DESCRIBE YOUR CHILDHOOD: Do you have a while? My childhood was never easy. My mother married five times, I only saw my father on weekends. I went to about five different elementary schools. Found out my father is gay. Watched my mom enter rehab three times. Made my father whiskey and water drinks. Fought with my younger sister. Saw my older sister on holidays. My mom used to randomly come and get me out of class and take me to one of her many doctor's appointments and then we'd go shopping, so that was fun. My dad would take us to the beach every Sunday in his Chevy with his bottle of "juice" and buy us a bag of candy. I think it was like church to him.

FUN, FUN IS MY MIDDLE NAME.

DESCRIBE A MAJOR EVENT OR ISSUE THAT'S AFFECTED YOUR FAMILY: Well, my dad being gay for one thing. Even though no one on his side of the family cares, because my aunt is a lesbian, so she kind of broke everyone in. My little sister had kind of a different reaction. She doesn't talk to him anymore and my mom doesn't help much because she always downs him in front of her. I don't mind at all; he is my dad, no matter what.

DESCRIBE A QUALITY/TRAIT THAT RUNS IN YOUR FAMILY: Hardheadedness, is that a word? I'm very persistent and my way is the right way. I don't know if this is a trait or not. I'm not really sure on this one. There isn't really any quality traits that run in my family.

WHAT IS THE MOST IMPORTANT ISSUE OR PROBLEM FACING YOU TODAY? Saving money, I really suck at it. I'm in debt up to my ears and I have no rent, no car payment, no car insurance, and I still have no money. I feel like I really need to get my s**t together, but hey, you only live once right?!

WHO ARE YOUR HEROES AND WHY? I think the last time I said Marilyn Monroe, she still is, but I also dig Martha Stewart. She's so crafty. I mean, who else do you know that can cook a gourmet feast, knit a tablecloth out of silk, build a grand dining room table out of marble by hand, paint the china and still be composed?

WHAT ARE YOUR THOUGHTS ON PEOPLE WHO HAVE A DIFFERENT SEXUAL ORIENTATION THAN YOU? I absolutely hate it when people talk demeaning about homosexuality since my dad is gay and I'm very protective. Your opinion is your opinion but if you say yours, expect a lot more of mine.

WHAT ARE YOUR THOUGHTS ON INTERRACIAL DATING? My first boyfriend was Laotian and I learned a lot. Whatever your flavor is, it's fine with me.

DO YOU HAVE ANY HABITS WE SHOULD KNOW ABOUT? I burp loud. I also pee with the door open. I take long showers. I put half-empty water bottles in the refrigerator. I pop my knuckles and my back.

WHAT BOTHERS YOU MOST ABOUT OTHER PEOPLE? When they correct me, act like they know everything, chew with their mouths open, don't flush the toilet, should I go on? When people eat in the bathroom and pick their noses and wipe it on the furniture. When people say stuff, hinting around for you to ask them what they are talking about even though you don't really care. I'll stop now.

DO YOU EVER FEEL INTIMIDATED BY OTHER PEOPLE? WHY? HOW DO YOU REACT IN THESE MOMENTS? Yes, very pretty girls and cops intimidate me. Pretty girls suck. For some reason we usually clash. When a pretty girl walks into a bar or a store, I look once and never look again, but I watch how other people react to her. Is this weird? Cops intimidate me because they're cops, they are mean power trippers who always cost you money!

IF YOU COULD CHANGE ONE THING ABOUT THE WAY YOU LOOK WHAT WOULD IT BE? Bigger boobs and thinner hips. I'm pretty small everywhere but recently I blossomed hips with no boobs. I know they are just a speed bump on the way down but mine are like those road turtle things that let you know you're over the line. Except they aren't big enough for you to feel them. All my bras are padded. Some boys call this false advertisement.

IF YOU COULD CHANGE ANY ONE THING ABOUT YOUR PERSONALITY WHAT WOULD IT BE? Nothing, I'm perfect. Ha! I would probably change my negative attitude. I'm usually the first to quit or say can't and I really hate that. I also say "hate" a lot.

IF YOU HAD ALADDIN'S LAMP AND THREE WISHES WHAT WOULD THEY BE? To have a phat house and no bills. Have lots of dollar bills. And world peace, right? No, I'd wish for three more wishes.

BRYNN: I think I was chosen because I have an intriguing family history and I think that there's something intriguing about myself. I am who I am, but there's always something there that you never really know. Even I feel like there's something there that I don't really know yet. And I'm energetic and outgoing and open to always try new things. Especially in Vegas—with my crazy-let's-go-party-and-meet-new-people-and-kiss-a-bunch-of-boys attitude. But I also knew I had a lot of potential to grow and that was probably the reason why I was chosen.

MARY-ELLIS BUNIM: Brynn is someone we talked a lot about because in the casting sessions she was quite provocative. She was very open about how she stirs things up, how she always goes after the guys, and how she is competitive with other women.

JONATHAN MURRAY: She's someone who said herself that she quit a lot of times in life on things, so part of the question with Brynn was would she quit on this or get through it?

DR. LAURA KORKOIAN: Brynn has no filter. She'll say what she wants to say; she'll do what she wants to do. She's a little troublemaker—a little instigator, someone who can't keep a secret. She's very engaging when you talk to her in an interview—the way she sort of draws you in. There's something with Brynn that makes you just want to join her and have fun with her. I thought, she'll be the one that people are just going to want to go out and have a good time with. There's something sort of intoxicating about her.

WHAT BROUGHT YOU TO **THE REAL WORLD**? I wanted to do *Real World* because I wanted to get to live with six unique individuals and to live in a phat house. For free. And get a job handed to me, and a car and have a great time and not have to really pay any bills and just live my life for four months. It's a free, awesome house. Who wouldn't want to do it?

How I got there was I tried out for an open call in Portland and ended up making it to finals for Chicago. But I ended up not making it, but six months go by and they end up calling me and saying, "You want to try out again?" So the process the second time was a lot easier for me. I just sent in a tape and did two interviews and I ended up making it on the show.

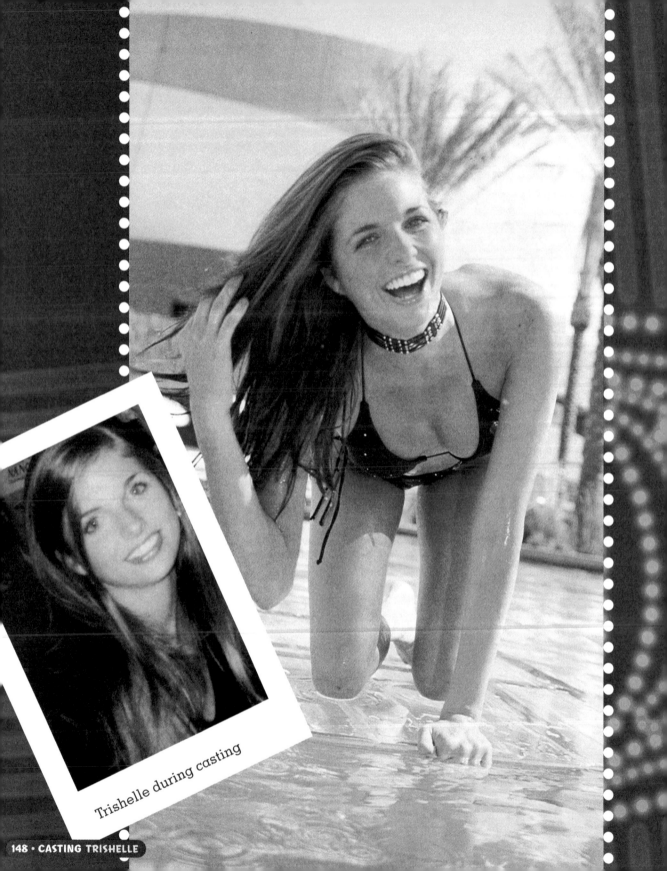

Trishelle during casting

Trishelle

NAME: Trishelle

AGE: 21

BIRTHDATE: November 4

PRESENTLY LIVING IN: Hattiesburg, MS

PARENTS: Andrew

SIBLINGS (NAMES AND AGES): Buffy, 31, Buffy, 24 (yes, another one—she's a stepsister.)

WHAT IS YOUR ETHNIC BACKGROUND? White, Caucasian, whatever

NAME OF HIGH SCHOOL: South Lafourche High School

NAME OF COLLEGE: University of Southern Mississippi. I'm a fifth-year senior. I don't know when I want to graduate.

WHERE DO YOU WORK? DESCRIBE YOUR JOB HISTORY: Oh, don't even get me started! I'm trying to get fired from the place I work (a fine-dining restaurant) anyway—I haven't showed up in two weeks, hoping they would fire me, and they keep calling to get me to come in and work. They suck!

WHAT ARTISTIC TALENTS DO YOU HAVE? HOW SKILLED ARE YOU? I was in singing and piano for four years and sometimes . . . when I get drunk . . . like I am now . . . I do this artistic expressional dance thing, you should see it! I'm kind of artsy-fartsy. I like to paint things. I took art for five years. That's how I like to let go of some anger.

WHAT ABOUT YOU WILL MAKE AN INTERESTING ROOMMATE? I'm always doing something. ALWAYS.

I have yet to find someone as weird as I am. I go out every night and I don't ever sleep. That drives people crazy, but I think it's fun! I love nighttime. I like to stir s**t up, too. I like to test people and see how far they'll let me go with them. I don't know why, that's kind of scandalous, but I do!

HOW WOULD SOMEONE WHO REALLY KNOWS YOU DESCRIBE YOUR BEST TRAITS? Well, like I always say—my best traits are someone else's worst. I am confident (a little too much sometimes) and competitive and outgoing and flirtatious. I'm smart, too. People don't think so, but I am. I know a lot of s**t! I surprise myself sometimes. I'm fun, fun, fun. I like to party—some people think too much. I just like to have fun.

HOW WOULD SOMEONE WHO REALLY KNOWS YOU DESCRIBE YOUR WORST TRAITS? I'm a little scandalous with boys. I mean I'm attracted to so many people—boys, girls, whatever. That's bad. I think it gets me in trouble. I want what I can't have. I have to win. That's a bad thing sometimes. I don't take things seriously enough. I am too spontaneous sometimes. I've ditched school for a week to follow Incubus.

DESCRIBE YOUR MOST EMBARRASSING MOMENT IN LIFE: There are so many! Last night we were at a bonfire at school and my jacket caught on fire! I am always doing something silly. One time I got really drunk and got onstage at a bar and sang "Hit Me With Your Best Shot" and I was so bad, they booed me off the stage and then some *white trash bitch* got onstage and sang it to the tee. That sucked!

"I don't know exactly what I want to do with my life, but I know I'm going to be sucessful. And I'm going to live in a big city and I'm probably going to do it by myself. I plan on meeting a lot of new people and exploring my horizons and not being racist. . . open my mind a little bit and get out of the South where everything is so closed in and sheltered."

DO YOU HAVE A BOYFRIEND OR GIRL-FRIEND? HOW LONG HAVE YOU TWO BEEN TOGETHER? WHERE DO YOU SEE THE RELATION-SHIP GOING? Hell, hell no! I dated a guy for three years and now he's engaged to a Pamela Anderson Lee look-alike! I slept with him while they were engaged and he was a total a**hole to me! I hate boys! I might have to resort to girls! Ha, ha. I am a little confused in that department. I have a crush on everyone.

WHAT QUALITIES DO YOU SEEK IN A MATE? Fun! Quirky, silly, funny, spontaneous, asses are good...

HOW IMPORTANT IS SEX TO YOU? DO YOU HAVE IT ONLY WHEN YOU ARE IN A RELATIONSHIP, OR DO YOU SEEK IT OUT AT OTHER TIMES? Surprisingly, I haven't been with that many people, maybe four, which isn't that much. Sex is important—but not necessary. I have a vibrator!

DESCRIBE YOUR FANTASY DATE: Going to the Riverwalk and sitting on the steps that lead down to the river with candles and Bud Light beer or cranberry-n-vodkas and a little Dave Matthews and some Trojans.

WHAT DO YOU DO FOR FUN? Everything I do is fun. When we have study groups, it's not in the library—it's at Coconuts (a bar and grill). I mostly like to travel, though. I like roadtrips and concerts and music and sports.

DO YOU PLAY ANY SPORTS? DESCRIBE YOUR ATHLETIC ABILITY: All of them. I'm captain of a flag-football team. I ran track for six years, softball, tennis, swim team, everything. I love sports and following them.

WHAT ARE YOUR FAVORITE MUSICAL GROUPS/ARTISTS? I go through my stages—when I sort of talked to Mike from Incubus, I liked them and 311 and someone left a Ben Harper CD in my car and I liked him. I have an appreciation for all music.

DESCRIBE A TYPICAL FRIDAY OR SATURDAY NIGHT: I usually have a couple of beers while I get dressed, then my girlfriends come over and we play "Indian" or "Presidents and A**holes" (card games) and go out to clubs, look for an after party at 2 A.M. and roll in at about 5:30 A.M.

DO YOU LIKE TRAVELING? DESCRIBE ONE OF TWO OF THE BEST OR WORST TRIPS YOU HAVE TAKEN: My 21st birthday last year was the best. I traveled with Incubus for four days on their tour bus. I was flown to Houston, Texas, and ended up in Jacksonville, Florida and flew from there to New Orleans. The whole trip was fun.

WHAT ARE SOME WAYS YOU HAVE TREATED SOMEONE WHO HAS BEEN IMPORTANT TO YOU THAT YOU ARE PROUD OF? I don't think you should get a "pat on the back" for treating someone good. I wouldn't say I've done anything special for someone that I'm *proud of*. My dad and sister are very important to me, and I really haven't done anything especially good or nice for them.

HAVE YOU EVER TREATED SOMEONE WHO IS IMPORTANT TO YOU IN A WAY THAT YOU NOW REGRET OR ARE EMBARRASSED BY? Yeah, I'm not very nice to my dad when I should be. He's more like a friend than a parent so it's hard to respect him in that way. But also my mom. She died and I've never been to her grave. I didn't even cry at her funeral. That's kind of crappy I guess but different people react in different ways. I don't think you should ever be embarrassed by anything you feel.

WHO IS THE MOST IMPORTANT PERSON IN YOUR LIFE RIGHT NOW? I guess my sister, Buffy (half sister, not stepsister). She is there for me when I need her and sometimes I call her at 3 A.M. crying and she talks to me. She tells me about our mom before she died because I don't remember much from when I was really young.

DESCRIBE YOUR CHILDHOOD: Well, lots of tragedy. My uncle shot my aunt and then shot himself when I was 12. I was very close to them and it was horrible. Then my mom died. When I was 14, got into LOTS of bad stuff (drugs, partying). I didn't really deal with things until I got to college. I'm a better person now (I hope). I don't do drugs, but I still drink and party like a rock star! I had a really bad childhood.

DESCRIBE A MAJOR EVENT OR ISSUE THAT'S AFFECTED YOUR FAMILY: My mom's death—my sister's crazy divorce—my dad's remarriage? Pick one.

DESCRIBE A QUALITY/TRAIT THAT RUNS IN YOUR FAMILY: Strong-willedness. All of the women in my family are hardheaded and strong-willed. We don't listen to anyone.

WHAT IS THE MOST IMPORTANT ISSUE OR PROBLEM FACING YOU TODAY? I try not to make things issues! My biggest problem presently is what to do tonight.

WHO ARE YOUR HEROES AND WHY? My sister Buffy (half sister). She's lost both of her parents, been through a divorce, and she has three kids. She's a strong, smart woman and I admire her for that.

I DON'T DO DRUGS, BUT I STILL DRINK AND PARTY LIKE A ROCK STAR!

WHAT ARE YOUR THOUGHTS ON PEOPLE WHO HAVE A DIFFERENT SEXUAL ORIENTATION THAN YOU? I've kissed girls, so yeah, it's okay. We just don't announce it to everyone.

WHAT ARE YOUR THOUGHTS ON INTERRACIAL DATING? No! I am so against this. I would never date a black guy. It's just not acceptable to my family.

DO YOU HAVE ANY HABITS WE SHOULD KNOW ABOUT? Not any fatal ones.

WHAT BOTHERS YOU MOST ABOUT OTHER PEOPLE? I hate fuddy-duddies—people who sit at home and don't do anything. Also, I hate it when people push their opinions/beliefs on other people. I don't want to listen to that s**t.

IF YOU COULD CHANGE ONE THING ABOUT THE WAY YOU LOOK WHAT WOULD IT BE? I want bigger boobs, like ridiculous big.

IF YOU COULD CHANGE ANY ONE THING ABOUT YOUR PERSONALITY WHAT WOULD IT BE? Nothing, I like my s**t.

IF YOU HAD ALADDIN'S LAMP AND THREE WISHES WHAT WOULD THEY BE? Stay 21, I'd be the most beautiful girl in the world, and I would wish for unlimited wishes.

I WANT BIGGER BOOBS, LIKE RIDICULOUS BIG.

WHAT BROUGHT YOU TO THE REAL WORLD? The experience of being here and meeting new people. I didn't know a lot of other people with different cultural backgrounds. I thought this was my chance to learn about other people's backgrounds and for them to learn where I come from.

TRISHELLE: I don't know. I'm so flattered, but I have no clue why I was cast.

MARY-ELLIS BUNIM: Trishelle is gorgeous. She walked in here and all the men in front and behind the camera went, "Oh my God!"

JONATHAN MURRAY: Which didn't make Brynn very happy. She already had jealousy issues with other women, then here comes Trishelle. We've been very successful with the fish out of water, the person from a small town who comes to a big city. And that's definitely Trishelle.

DR. LAURA KORKOIAN: A lot of people can identify with people who have lost someone so close to them at such a young age. Trishelle has all that vulnerability and so many unresolved issues from her mother passing away so suddenly. It was very interesting to see at the end of this experience what she might learn about and what she still needs to do to have some closure. Also, Trishelle has a lot of charm. She loves to have a good time and is very sweet. Outside of all that beauty is just this young woman who is still trying to find herself.

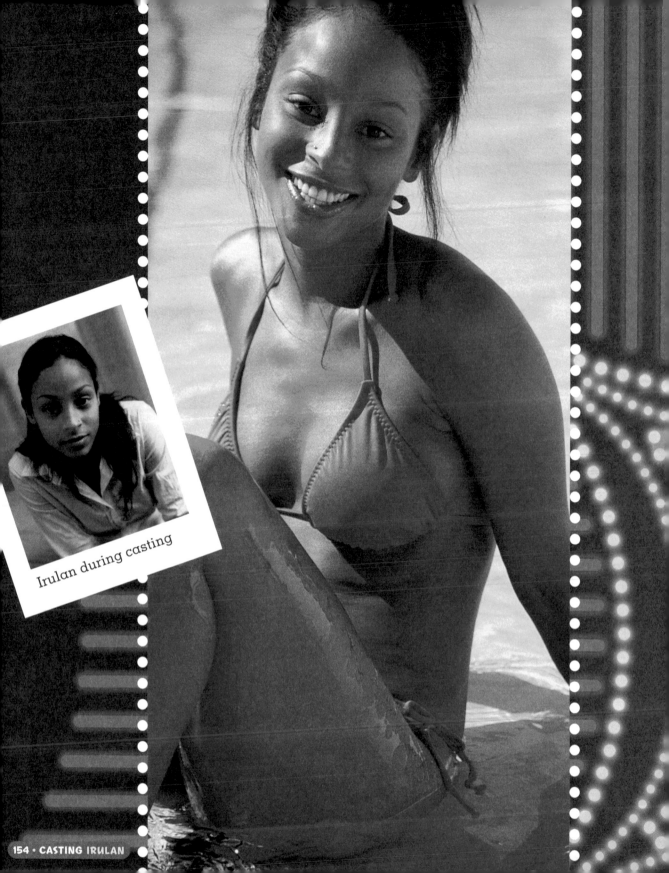

Irulan during casting

NAME: Irulan

AGE: 21

BIRTHDATE: April 5

PRESENTLY LIVING IN: Bronx, NY

PARENTS: Jeannette

SIBLINGS (NAMES AND AGES): None

WHAT IS YOUR ETHNIC BACKGROUND?: Half Italian, half black

NAME OF HIGH SCHOOL: Hunter College High School

NAME OF COLLEGE: Parsons School of Design (freshman, sophomore, junior), SUNY Purchase (1 semester, liberal studies)

WHERE DO YOU WORK? DESCRIBE YOUR JOB HISTORY: I am not working right now but for the past three years up until this September I've worked as a cocktail waitress in various clubs/lounges around NYC.

WHAT IS YOUR ULTIMATE CAREER GOAL? I would love to shoot for *National Geographic*. I'd be able to travel, take pictures, have my work published, and get paid. That would be a dream come true.

WHAT ARTISTIC TALENTS DO YOU HAVE? HOW SKILLED ARE YOU? I am a photographer. I take a lot street stuff, mostly documentary work—black-and-white and color. I am in the process of hopefully getting some of my work published in a small Parisian magazine. And, I am still in school seeking a Bachelor of Fine Arts.

WHAT ABOUT YOU WILL MAKE AN INTERESTING ROOMMATE? I am an open book. It's just my nature to be pretty up front. I share myself very easily with people I click with initially (I think it often helps people feel comfortable around me). I am spontaneous in an off-the-wall sort of way. I think I am a person who definitely likes to have fun. I am smart, and I think I have good conversation skills. I grew up in NYC with a white single mother and brown skin. I've seen and learned a lot from my cocktailing days. I think I've lived and learned a lot for 21.

HOW WOULD SOMEONE WHO REALLY KNOWS YOU DESCRIBE YOUR BEST TRAITS? I give a great deal of energy and support to those I care about. I make people laugh. And I am a very loyal friend. Oh, and I'll always tell it how it is. I don't hold anything back. People always know where they stand with me.

HOW WOULD SOMEONE WHO REALLY KNOWS YOU DESCRIBE YOUR WORST TRAITS? I'll always tell it how it is.... Sometimes I don't think before I speak and my opinions come out differently than I mean them. I'm pretty stubborn, and I like things the way I like them. All right I can be a real bitch sometimes. There, I said it.

DESCRIBE YOUR MOST EMBARRASSING MOMENT IN LIFE: I don't know really. I embarrassed a lot easier when I was little. Now things don't seem to matter in the same way. A loud belch in a crowded elevator just makes me laugh, and gives me a little character, maybe.

DO YOU HAVE A BOYFRIEND OR GIRLFRIEND? HOW LONG HAVE YOU TWO BEEN TOGETHER? WHERE DO YOU SEE THE RELATIONSHIP GOING? I do have a boyfriend, his name is Gabe. We have been together for three years but we've known each other since

junior high school. We're like high school sweethearts, but with a few dirty little secrets. . . . We are best friends and lovers, and it works well for us. Gabe really knows me and that is a great feeling . . . to be understood. Also, he is super laid-back and positive and I like to be around that type of energy. And, he's brilliant (1550 on his SATs first time without studying). I wasn't always so rah-rah about him but I learned if you love somebody you have to love all of them (including s***ty, annoying little qualities that you could never change anyway).

WHAT QUALITIES DO YOU SEEK IN A MATE? Honesty, humor, intelligence, charm, sincerity, good looks, and a hard body. You know, all the essentials.

HOW IMPORTANT IS SEX TO YOU? DO YOU HAVE IT ONLY WHEN YOU ARE IN A RELATIONSHIP, OR DO YOU SEEK IT OUT AT OTHER TIMES? Sex is good s**t. But in my experience, casual sex is never all it's cracked up to be. Personally, I think it's a little weird to rub genitals with a perfect stranger. But then again, sometimes s**t happens. Gabe and I have a very healthy sex life when we are together and it's great. As a matter of fact, I had drunken, sweaty sex last night.

DESCRIBE YOUR FANTASY DATE: Doing anything with my baby. I'm happy with good food and conversation. I'm happier with all of the above and passionate love making on a sandy beach somewhere we might be discovered.

WHAT DO YOU DO FOR FUN? Whatever the moment calls for.

DO YOU PLAY ANY SPORTS? DESCRIBE YOUR ATHLETIC ABILITY: I played softball in high school. I was all-city two years in a row (shortstop and center field). I was a gymnast when I was younger but now basically I drive as much as

HEARD IN CASTING

"I'VE NEVER BEEN TO VEGAS BEFORE. I THINK IT'S GOING TO BE SO MUCH FUN. AND PHOTOGRAPHICALLY, TO EXPLORE THE CITY AND JUST THE DIFFERENT DYNAMICS BETWEEN ALL THE GLITZ AND THE GLAMOUR AND THEN THE PEOPLE THAT LIVE THERE. BUT I'M SCARED THAT I MIGHT GET IN TROUBLE WITH GABE. BUT OTHER THAN THAT I DON'T THINK I'LL TURN INTO LIKE A GAMBLING ADDICT OR AN ALCOHOLIC OR ANYTHING BAD LIKE THAT. I JUST THINK THAT MAYBE BETWEEN MY SHOWS AND THE STRIP CLUBS AND THE BARS AND PEOPLE IN THE HOUSE AND WHOEVER, THAT MAYBE SOMEBODY MIGHT TICKLE MY FANCY."

loves you, she's there to support you, no matter what. That's what I love most about my mom.

DESCRIBE A MAJOR EVENT OR ISSUE THAT'S AFFECTED YOUR FAMILY: My dad dying was the most major event that my family has ever experienced. He was only 37 years old. And it turned everything upside down. And on top of that, he didn't have life insurance, so we were poor too. Since then my mom and I have been extremely close and pretty isolated from our extended family.

DESCRIBE A QUALITY/TRAIT THAT RUNS IN YOUR FAMILY: My mom and I are both pretty accepting of all people (white, black, blue, yellow, gay, straight, poor, rich, fat, thin…) I am very thankful I was raised not to judge anyone superficially.

WHAT IS THE MOST IMPORTANT ISSUE OR PROBLEM FACING YOU TODAY? In light of recent world events, I'd like to say something real PC like "world peace." But, really my answer is paying my bills and juggling my school schedule. Then, world peace. I don't mean to sound bitter, I'm just tired of struggling.

possible and smoke cigarettes. But I've been blessed with a naturally athletic body.

WHAT ARE YOUR FAVORITE MUSICAL GROUPS/ARTISTS? Sade, Al Green, Stevie Wonder, Bob Marley, Fela, Biggie, Otis Redding, Bill Withers, Mos Def, Outkast, Erykah Badu.

DESCRIBE A TYPICAL FRIDAY OR SATURDAY NIGHT: Now that I'm back in school I spend all day in the dark room on the weekend. So usually I just like to meet some friends for a drink or just curl up with a movie. Simple.

DO YOU LIKE TRAVELING? DESCRIBE ONE OR TWO OF THE BEST OR WORST TRIPS YOU HAVE TAKEN: I love to travel! It's really the only way to learn. I recently spent four months in Brazil with my boyfriend and one other friend. I had the time of my life. I went to the beach, explored and shot pictures, heard great music, danced my ass off, met interesting people, learned Portuguese, ate great food. It was truly the best. Next on my list, either South Africa or Central America.

DESCRIBE YOUR CHILDHOOD: I had a lot of love. My parents worked hard to give me a good foundation. I went to a good school, I had good toys, and I was an only child, so I was a spoiled little brat. My father died a month before my seventh birthday, so clearly we had challenges. But I had so much fun growing up, so many great memories, and good friends.

WHO IS THE MOST IMPORTANT PERSON IN YOUR LIFE RIGHT NOW? My mom. She is so special. She has a huge heart with a lot of love. And when she

WHO ARE YOUR HEROES AND WHY? I can't say that I really have a hero. There are people who influence me, but not one dominant source of inspiration.

WHAT ARE YOUR THOUGHTS ON PEOPLE WHO HAVE A DIFFERENT SEXUAL ORIENTATION THAN YOU? Anything goes, really.

WHAT ARE YOUR THOUGHTS ON INTERRACIAL DATING? Right on.

WHAT BOTHERS YOU MOST ABOUT OTHER PEOPLE? I guess it bothers me most when people lie.

IF YOU COULD CHANGE ONE THING ABOUT THE WAY YOU LOOK WHAT WOULD IT BE? I don't know . . . I just try to work with what I got.

IF YOU COULD CHANGE ANY ONE THING ABOUT YOUR PERSONALITY WHAT WOULD IT BE? This is a hard one. I think I am constantly trying to be the best I can be. So I guess it's always changing. But if I had to name one thing, I suppose it would be that I wish I could express myself in a more warm, fuzzy way. I have a tendency to be blunt—which can be offensive in certain situations.

IF YOU HAD ALADDIN'S LAMP AND THREE WISHES, WHAT WOULD THEY BE? I'd wish: that my dad never died. For the health and happiness of everyone I love, and of course, world peace.

I WISH I COULD EXPRESS MYSELF IN A MORE WARM, FUZZY WAY.

WHY IRULAN WAS CAST

WHAT BROUGHT YOU TO THE THE REAL WORLD? What I know now is that I was applying for the Chicago season, but I thought that I was applying for the New York season. I sent my tape in with my best friend, Dena. We thought, wouldn't it be great to live in an amazing loft in New York, where we live, still be able to go to school, and be able to have our friends over? We wanted to try to do it as best friends and offer a new idea.

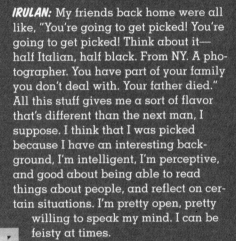

IRULAN: My friends back home were all like, "You're going to get picked! You're going to get picked! Think about it—half Italian, half black. From NY. A photographer. You have part of your family you don't deal with. Your father died." All this stuff gives me a sort of flavor that's different than the next man, I suppose. I think that I was picked because I have an interesting background, I'm intelligent, I'm perceptive, and good about being able to read things about people, and reflect on certain situations. I'm pretty open, pretty willing to speak my mind. I can be feisty at times.

MARY-ELLIS BUNIM: She's a beautiful young lady, incredibly articulate, with a great sense of humor, and a great sense of playfulness and fun.

JONATHAN MURRAY: There's a bit of an aloofness and wariness to Irulan. You're not quite sure how she's going to react to you or what she's thinking. I think that makes for an interesting character because she's a little unpredictable in that sense of what's she's going to do next.

DR. LAURA KORKOIAN: Irulan is in this place of trying to figure out who she is—the growing is not done yet. We knew that we would be able to watch this young, tough woman from the Bronx, who has this precious, very vulnerable heart, learn about herself through her interactions with her other roommates. And you see this woman with some insecurities—a woman who's dealt with a lot already in her life. I loved her sense of who she was, that she knew who she was. But I knew there was so much more that she didn't even realize she could learn about herself by being here.

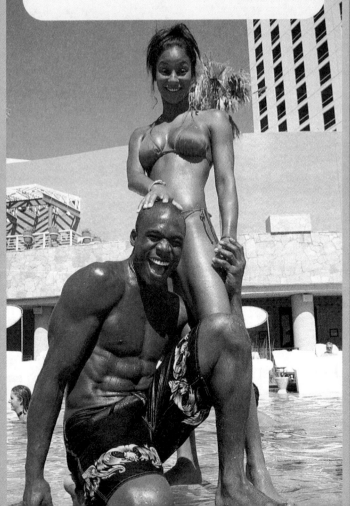

Steven during casting

CASTING

Steven

NAME: Steven

BIRTHDATE: May 19

PRESENTLY LIVING IN: San Marcos, TX

PARENTS: Judith

SIBLINGS (NAMES AND AGES): Terrence, 25, Terra, 36, Chuck, 33.

WHAT IS YOUR ETHNIC BACKGROUND?: My dad is Jewish and my mom is blond-haired, blue-eyed Catholic German.

NAME OF HIGH SCHOOL: Marshall High

NAME OF COLLEGE: Southwest Texas State University, 3 years, Business Management Major

WHERE DO YOU WORK? DESCRIBE YOUR JOB HISTORY: I work as a bartender at a gay club called the Boyz Cellar. I flirt and make drinks with my shirt off from Thursday to Sunday. I love my job and coworkers.

WHAT ARTISTIC TALENTS DO YOU HAVE? HOW SKILLED ARE YOU? I have recently gotten into photography. I am new at it, so I am not that great yet.

WHAT ABOUT YOU WILL MAKE AN INTERESTING ROOMMATE? I am 23 and already have a divorce under my belt. I was a model in Manhattan. I am a topless bartender at a gay bar. I have also been through five divorces with my mom. I have attended twenty-four schools, had twenty-five jobs, and lived in five states, (including the state of confusion). I am outgoing and always attempt to include everyone during social occasions. I am also a terrible flirt and a little too promiscuous for my own good.

HOW WOULD SOMEONE WHO REALLY KNOWS YOU DESCRIBE YOUR BEST TRAITS? A huge dork! I am definitely not consistent with my looks. They would say that if Steven isn't tripping over something or saying something dumb, he is making a mess. My best trait is being a goofball. Oh yeah, and that I am always way too happy and always find the silver lining in every situation.

HOW WOULD SOMEONE WHO REALLY KNOWS YOU DESCRIBE YOUR WORST TRAITS? That when working in a team environment I tend to dominate. I am a perfectionist when it comes to work, I want everyone to work as hard as I do. I can be a little harsh on people when they don't perform to the best of their ability. In contrast, I am always quick to recognize people for their achievements.

DESCRIBE YOUR MOST EMBARRASSING MOMENT IN LIFE: At the Boyz Cellar, my boss wanted me to get interviewed for our being in the running for best gay bar. There were two shots, one with me bartending with no shirt on and one with my shirt on and not bartending. For the first shot, I spilled a huge drink on the pretty reporter's dress. Once again, I am a dork.

DO YOU HAVE A BOYFRIEND OR GIRLFRIEND? HOW LONG HAVE YOU TWO BEEN TOGETHER? WHERE DO YOU SEE THE RELATIONSHIP GOING? I just got divorced. I can't be thinkin' about datin' anyone. I have been in slut mode for the past seven months. Eventually I would love a girlfriend.

161

WHAT QUALITIES DO YOU SEEK IN A MATE? Intelligence, SENSE OF HUMOR, looks, and the ability to handle my being an IDIOT!

HOW IMPORTANT IS SEX TO YOU? DO YOU HAVE IT ONLY WHEN YOU ARE IN A RELATIONSHIP, OR DO YOU SEEK IT OUT AT OTHER TIMES? On October 18, I pledged to not have sex for one month. Yeah, that lasted six days. I am very sexually active and not in a relationship. The last time I had sex I was called at 4:20 A.M. by a woman that I have a special relationship with. I went over, we talked, and then had some really rough sex at her request. Like my art teacher used to say, "Variety is the spice of life."

DESCRIBE YOUR FANTASY DATE: For a first date, I really just want to go to a quiet restaurant to talk and get to know the girl. After that, maybe something cliché, like walk on the beach at night with some champagne. If I am on a date, I don't like to mess around. Maybe one kiss, but that's it.

WHAT DO YOU DO FOR FUN? I love to watch movies. I don't care if I have to go alone, I will see at least one movie a week. I also work out five times a week and try to do something new each week. I am always up for new things.

DO YOU PLAY ANY SPORTS? DESCRIBE YOUR ATHLETIC ABILITY: When I was 13, I was ranked nationally for the javelin. I competed in the Junior Olympic nationals. All around, I am a pretty good athlete.

WHAT ARE YOUR FAVORITE MUSICAL GROUPS/ARTISTS? Right now I am listening to Gorillaz, Sarah McLachlan, and Bubba Sparx.

DESCRIBE A TYPICAL FRIDAY OR SATURDAY NIGHT: I work on Friday and Saturday night. I hit the gym for a quick workout and then go to work. At work, I quickly set up my station, take off my shirt and make money. I am busy flirting with men, women, and people that could go either way. Usually I start a conversation with a cute girl and spend the night with her.

DO YOU LIKE TRAVELING? DESCRIBE ONE OR TWO OF THE BEST OR WORST TRIPS YOU HAVE TAKEN: I love to travel! The best trip that I have taken was when I moved to Manhattan. I remember walking around one night from Lexington Ave. through Park Place to Penn Station. The whole time was just this huge surreal moment. I felt at peace.

WHAT ARE SOME WAYS YOU HAVE TREATED SOMEONE WHO HAS BEEN IMPORTANT TO YOU THAT YOU ARE PROUD OF? I am really open with how I feel, partly thanks to hanging out with gay guys. My older brother, Terrence, has changed so much. I told him that I really liked the person that he has become and that I love him and will always be there for him. We had never really talked to each other like that before.

I AM ALWAYS WAY TOO HAPPY AND ALWAYS FIND THE SILVER LINING IN EVERY SITUATION.

HAVE YOU EVER TREATED SOMEONE WHO IS IMPORTANT TO YOU IN A WAY THAT YOU NOW REGRET, OR ARE EMBARRASSED BY? I had a huge fight with my brother's girlfriend. My brother tried to calm me down and I threatened to kick his ass and said some really horrible things to him. I was really young then and am still ashamed by how I acted.

DESCRIBE YOUR CHILDHOOD: I lived with my mom and brother Terrence until 13 years old. My mom has been married five or six times so we moved around at least twice a year. Growing up, I have been wealthy, middle-class, and welfare poor. I remember buying clothes at Goodwill and shopping for food with my mom paying with food stamps. At 13, I moved in with my sister in Ohio, then back to Texas. I would not trade a moment of my childhood for anything for it has made me the person I am today.

DESCRIBE A MAJOR EVENT OR ISSUE THAT'S AFFECTED YOUR FAMILY: When I was 11 years old my step dad came home drunk and started hitting my mom. My brother called the cops and I ran in and said, "Hey, a**hole get the hell away from her." He chased after me and she got away. My mother, brother, and I moved into the crisis center and lived on welfare for the next year and a half.

DESCRIBE A QUALITY/TRAIT THAT RUNS IN YOUR FAMILY: We are all very charismatic. I don't know if we

are charming or manipulative, but people always remember people from my family and want to do things for us.

WHAT IS THE MOST IMPORTANT ISSUE OR PROBLEM FACING YOU TODAY? I am trying to figure out what I am passionate about. I have all of this creative energy and no outlet. I lack purpose and am deathly afraid of not being good at anything or missing my calling.

WHO ARE YOUR HEROES AND WHY? My friend Daniel is my hero. He is always so positive and nice. Everyone likes Daniel because he is this amazingly genuine and nice person. I aspire to be like him.

WHAT ARE YOUR THOUGHTS ON PEOPLE WHO HAVE A DIFFERENT SEXUAL ORIENTATION THAN YOU? I work at a gay bar and have a best friend that is gay, so I am cool with it.

WHAT ARE YOUR THOUGHTS ON INTERRACIAL DATING? I date other races, so I am all for it.

DO YOU HAVE ANY HABITS WE SHOULD KNOW ABOUT? I treat exercise like a habit. That's about it.

WHAT BOTHERS YOU MOST ABOUT OTHER PEOPLE? When people pretend to be something they are not. I am a dorky college kid that works at a gay bar. I act the same way everywhere. Well, maybe more flirty at work.

IF YOU COULD CHANGE ONE THING ABOUT THE WAY YOU LOOK WHAT WOULD IT BE? If there is a genie that is offering to change something about me I would want a bigger chest. I am pretty comfortable with how I look, so, I don't sit around dwelling on it.

IF YOU COULD CHANGE ANY ONE THING ABOUT YOUR PERSONALITY WHAT WOULD IT BE? I work on my personality every day. Each day, my goal is to be a better person than the day before. I try to be nice to everyone, but that doesn't always work.

IF YOU HAD ALADDIN'S LAMP AND THREE WISHES, WHAT WOULD THEY BE? I am in such a good place right now I wouldn't need that. I wake every morning with an ear-to-ear smile—that makes me pretty fortunate. If I had to pick: 1. Some amazing artistic ability. 2. World peace. 3. A huge penis (like 11 inches or something).

WHY STEVEN WAS CAST

WHAT BROUGHT YOU TO THE REAL WORLD? This girl who lives in my complex is a theater major, and she was going to *The Real World* open call and asked me if I wanted to go with her. And I figured, well, I don't have class until 2, so I went!

I AM A DORKY COLLEGE KID THAT WORKS AT A GAY BAR.

STEVEN: I've gone such a strange path. It almost seems like my whole life has groomed me to do something like this. I've lived everywhere and been to twenty-four schools. My mom's been married five or six times, and I've been married and divorced. I was a model in New York. I was working as a topless bartender in a gay bar. My background is strange and interesting and I'm proud of that. I guess that's why I'm here.

MARY-ELLIS BUNIM: I don't know what to add to that except that Steven's enormously likeable and I think a lot of that has to do with his charm and his smile. He knows those are his lethal weapons and he used them well.

JONATHAN MURRAY: Steven is one of those guys that is just so charming. He has an amazing smile, and he's a bit of a rogue. There's a mischievous quality to him and he gets away with so much because of that smile. He's a little bit of a bad boy, but you just can't help but love him. And I think women know they are headed for trouble with him but they just can't help themselves. Plus, he has such a great back story in terms of having already been married and in the process of getting a divorce. He's been through a lot in his life in a short amount of time. We thought it would be interesting if he could share that with some of the cast members and they could grow from some of the experiences he's had in his life.

DR. LAURA KORKOIAN: Steven is funny, charming, and he loves to have fun. He was like a little kid to me. We had a talent portion in our casting in the finals. Steven brought out a toy accordion and played this Britney Spears song. It's nice to see that even though he's 24 years old there's still a very childlike youthful spirit about Steven that is very engaging and that's nice to have in a house environment.

CASTING
Application Instructions

1. Please fill out the enclosed application legibly.

2. Use dark-colored ink.

3. Answer all questions honestly and to the best of your ability.

4. Please write only on the printed side of the paper. Feel free to attach additional sheets as necessary.

5. Attach a page to this packet with a recent photo on it. (Yes, another one, even if you sent one with your original tape.)

6. You must staple a copy of your driver's license to the back of the packet.

7. Application should be accompanied by your video cassette. For more information, contact:
 www.bunim-murray.com
 www.mtv.com

 Mail the original copy and your video cassette to:
 Real World Casting Department
 6007 Sepulveda Blvd.
 Van Nuys, CA 91411

8. Please make sure to include enough postage when you return this packet.

THANK YOU FOR YOUR TIME AND EFFORT IN COMPLETING THIS PACKET.

Bunim/Murray Productions, Inc.
6007 Sepulveda Blvd.
Van Nuys, CA 91411
Casting info: http: // www. bunim-murray. com Date received:_____

THE REAL WORLD *Application form*

Name: _____

INTRODUCTORY INFO:

Present address: Phone: _____

_____ 2nd Phone: _____

_____ Cell/Pgr: _____

_____ email: _____

_____ I check my email a lot: Yes ☐ No ☐

_____ 2nd email: _____

Birthdate: _____ Age: _____

Social Security No.: _____ _____

Mother's Name, Phone, and Address: Father's Name, Phone, and Address:

Check here if this is your permanent address: ☐ Check here if this is your permanent address: ☐

_____ _____

_____ _____

_____ _____

_____ _____

Do you have any children? (names and ages): _____

Siblings? (names and ages): _____

What is your ethnic background? _____

Are you or have you ever been a member of SAG/AFTRA? Have you ever acted or performed outside
of school? _____

EDUCATION:

Name of High School (and years completed)

Name of College (years completed and majors)

Other education:

Where do you work? Describe your job history:

What is your ultimate career goal?

What kind of pressure do you feel about making decisions about your future? Who's putting that pressure on you?

What artistic talents do you have (music, art, dance, performance, film/video making, writing, etc.)? How skilled are you?

What about you will make you an interesting roommate?

If you're living with a roommate, how did you hook up with him or her? Tell us about him or her as a person. Do you get along? What's the best part about living with him or her? What's the hardest part about it?

How would someone who really knows you describe your best traits?

How would someone who really knows you describe your worst traits? _____

Describe your most embarrassing moment in life: _____

Do you have a boyfriend or girlfriend? How long have you two been together? Where do you see the relationship going? What drives you crazy about the other person? What's the best thing about the other person? _____

What qualities do you seek in a mate? _____

How important is sex to you? Do you have it only when you're in a relationship, or do you seek it out at other times? How did it come about on the last occasion? _____

Describe your fantasy date: _____

What do you do for fun? _____

Do you play any sports? Describe your athletic ability: _____

Describe yourself as a competitor: _____

What are your favorite musical groups/artists? _____

Describe a typical Friday or Saturday night: _____

What is the biggest scam you've ever pulled?

What was the last unusual, exciting, or spontaneous outing you instigated for you and your friends?

Do you like traveling? Describe one or two of the best or worst trips you have taken. Where would you most like to travel?

Other than a boyfriend or girlfriend, who is the most important person in your life right now? Tell us about him or her:

What are some ways you have treated someone who has been important to you that you are proud of?

Have you ever treated someone who is important to you in a way that you now regret or are embarrassed by?

Describe your childhood:

If you had to describe your mother (or your stepmother, if you lived with her most of your life as a child), by dividing her personality into two parts, how would you describe each part?

If you had to describe your father (or your stepfather), by dividing his personality into two parts, how would you describe each part?

How did your parents treat each other? (Did your parents have a good marriage? What was it like?)

Describe how conflicts were handled at home as you were growing up (who would win and who would lose, whether there was yelling or hitting, etc.): _____

If you have any brothers or sisters, are you close? How would you describe your relationship with them? _____

Describe a major event or issue that's affected your family: _____

Describe a quality/trait that runs in your family: _____

What is the most important issue or problem facing you today? _____

Is there any issue, political or social, that you're passionate about? Have you done anything about it? _____

Who are your heroes and why? _____

Do you believe in God? Are you religious or spiritual? Do you attend any formal religious services? _____

What are your thoughts on: _____

Abortion? _____

Interracial dating? _____

People who have a different sexual orientation from you? _____

The environment? _____

Politicians and people running for political office? _____

The military? _____

Gun control? _____

Affirmative action?

Animal rights?

Do you have any habits we should know about?

Do you have any allergies (i.e., insect bites, prescription medication)? If so, what are they?

Do you: Smoke cigarettes? Circle (Yes/No) Drink alcohol? (Yes/No) If yes, what is your favorite alcoholic beverage?

Do you smoke marijuana or use hard drugs? Have you ever? Please explain?

The Real World has a zero tolerance drug policy. If you use drugs, can you go without for several months?

Are you on any prescription medication? If so, what, and for how long have you been taking it?

Are you now, or have you ever seen a therapist or psychologist? If so, explain.

Have you ever been arrested or had a restraining order issued against you? (If so, what were the circumstances and what was the outcome?)

What bothers you most about other people?

Describe a recent major argument you had with someone. Who usually wins arguments with you? Why?

Have you ever hit anyone in anger or self-defense? If so, tell us about it (how old were you, what happened, etc.)

How do you handle conflicts? Do you feel that this approach is effective?

Do you ever feel intimidated by other people? Why? How do you react in these moments?

Have you ever intervened to stop an argument or fight? In your opinion, when does an argument escalate to the point where it should be stopped?

If you could change any one thing about the way you look, what would that be?

If you could change any one thing about your personality, what would that be?

If selected, is there any person or part of your life you would prefer not to share? If so, describe (i.e., family, friends, business associates, social organizations, or activities).

Is there anyone among your family or close friends who would object to appearing on camera? If so, why?

What is your greatest fear and why?

If you had Aladdin's lamp and three wishes, what would they be?

Please draw a self-portrait in the space below:

Please comment on your preferences for the following activities:

Comment:

Read books

Sleep 8 hours

Watch television daily, which shows?

Shop

Go out/party

Spend time with friends

Spend time alone

Balance work/study

Talk on the phone

Cook

Clean

Write/e-mail

Read newspapers (which sections?)

Play with animals

State opinions

Ask opinions

Confide in your parents

Volunteer

Procrastinate

Eat

Get drunk

Diet

Vote

Cry

Laugh

Instigate

Cinema

Theater

Concerts

Clubs

Parties

Surf the Web

My favorite Web sites are:

List 4 people who have known you for a long time and will tell us what a great person you are (excluding relatives). Please include two adults and two of your friends.

Name/Address/Phone/How do they know you?

1. _____

2. _____

3. _____

4. _____

Please help us get in touch with you. If you have other people (roommates, boyfriend/girlfriend, boss, relatives, etc.) who frequently know where you are and how to get in touch with you, please list them below. As we cast on a short schedule, getting in touch with you quickly helps everyone.

Name	Relation	Phone

How familiar are you with *The Real World*? _____

How did you hear about our casting search? _____

I acknowledge that everything stated in this application is true. I understand that any falsely submitted answers can and will be grounds for removal from the application process and from my subsequent participation in the final series. I further acknowledge and accept that this application form and the video tape I previously submitted to MTV will become the property of MTV and will not be returned. By signing below, I grant rights for MTV/Bunim-Murray productions (BMP) to use any biographical information contained in this application, my home video, or taped interview, and to record, use, and publicize my home video tape or taped interview, voice, actions, likeness, and appearance in any manner in connection with *THE REAL WORLD*.

Signature _____ Date _____

Please remember to staple a photocopy of your driver's license or passport to this packet. When faxing, do not include the photocopy. Thank you for your time and effort in completing this form.